CANON
EOS Digital Rebel
XSi/450D

Focal Digital Camera Guides

CANON EOS Digital Rebel XSi/450D

Christopher Grey

AMSTERDAM • BOSTON • HEIDELBERG • LONDON
NEW YORK • OXFORD • PARIS • SAN DIEGO
SAN FRANCISCO • SINGAPORE • SYDNEY • TOKYO

Focal Press is an imprint of Elsevier

Focal
Press

Focal Press is an imprint of Elsevier
30 Corporate Drive, Suite 400, Burlington, MA 01803, USA
Linacre House, Jordan Hill, Oxford OX2 8DP, UK

 Recognizing the importance of preserving what has been written, Elsevier prints its
books on acid-free paper whenever possible.

Library of Congress Cataloging-in-Publication Data
Grey, Christopher.
 Canon EOS digital rebel XSi/450d / Christopher Grey.
 p. cm. – (Focal digital camera guides)
 Includes index.
ISBN 978-0-240-81066-9 (pbk. : alk. paper) 1. Canon digital cameras–Handbooks,
manuals, etc. 2. Digital cameras–Handbooks, manuals, etc. I. Title.
TR263.C3G76 2008
771.3'3–dc22

 2008028486

British Library Cataloguing-in-Publication Data
A catalogue record for this book is available from the British Library.

ISBN: 978-0-240-81066-9

For information on all Focal Press publications
visit our website at www.books.elsevier.com

08 09 10 11 12 5 4 3 2 1

Printed in the United States of America

Typeset by Charon Tec Ltd., A Macmillan Company. (www.macmillansolutions.com)

Table of Contents

Part 4: Lenses

Part 5: The Subjects

Part 6: Accessories

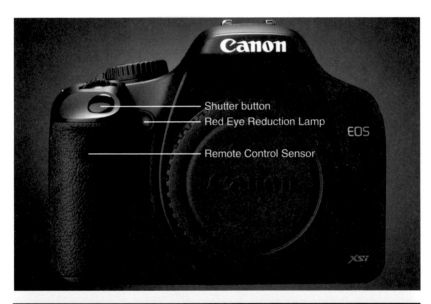

Shutter button
Red Eye Reduction Lamp
Remote Control Sensor

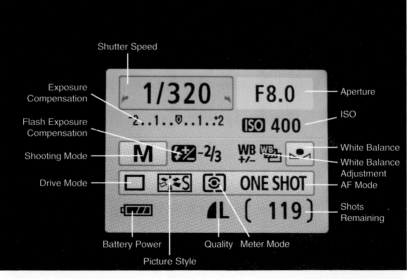

Shutter Speed

1/320 F8.0

Exposure Compensation

Aperture

ISO

Flash Exposure Compensation

White Balance

Shooting Mode

White Balance Adjustment

Drive Mode

AF Mode

ONE SHOT

Shots Remaining

Battery Power

Quality Meter Mode

Picture Style

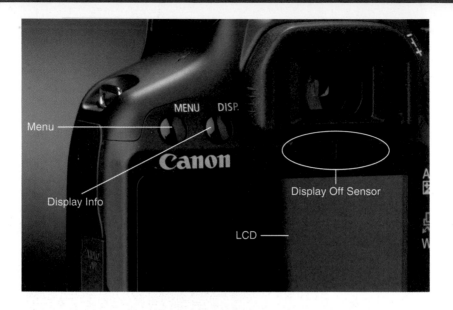

Menu

Display Info

MENU DISP.

Canon

Display Off Sensor

LCD

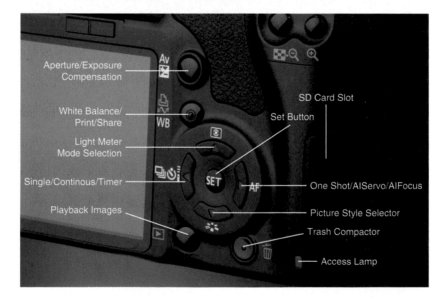

Aperture/Exposure
Compensation

White Balance/
Print/Share

Light Meter
Mode Selection

Single/Continous/Timer

Playback Images

SD Card Slot

Set Button

One Shot/AIServo/AIFocus

Picture Style Selector

Trash Compactor

Access Lamp

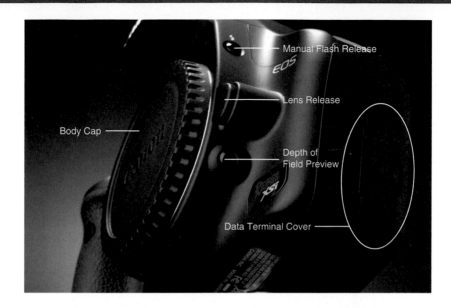

Manual Flash Release

Lens Release

Body Cap

Depth of
Field Preview

Data Terminal Cover

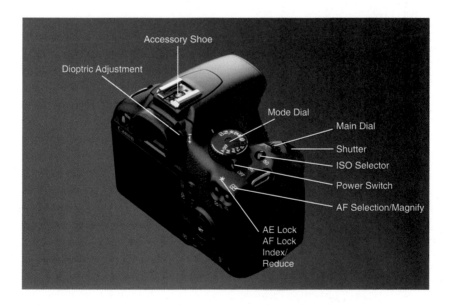

Accessory Shoe

Dioptric Adjustment

Mode Dial

Main Dial

Shutter

ISO Selector

Power Switch

AF Selection/Magnify

AE Lock
AF Lock
Index/
Reduce

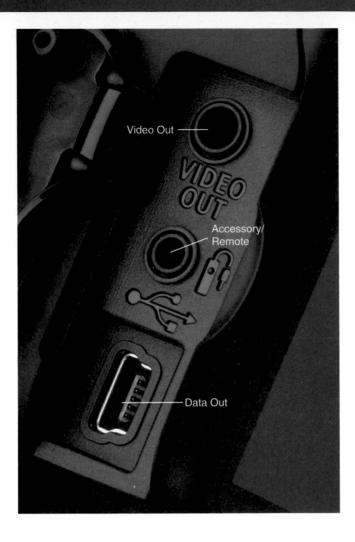

Video Out

Accessory/
Remote

Data Out

Quick Start

Up and Running in Five Minutes

Before you take your first pictures, you'll need to fully charge the battery. Insert the battery.

Attach a lens. If you're using an EF-S lens, align it with the white index mark on the camera's mounting ring. All other lenses will align with the red index mark. Once aligned, turn the lens clockwise until it locks.

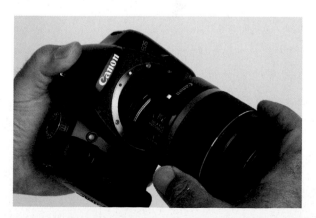

Set the lens Focus Mode switch to AF (Auto Focus)

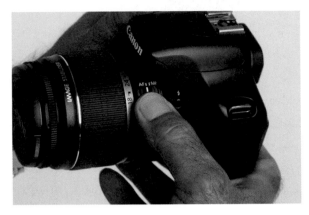

The first time you turn the camera on you'll be prompted to set the date and time. Use the Set button and the Cross Keys to scroll through the items and select the correct numbers. Click OK when finished.

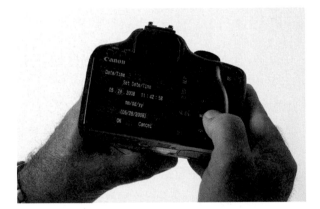

You may be prompted to select the Interface language. Select Language from the menu and use the Cross Keys and the Set button to make your selection.

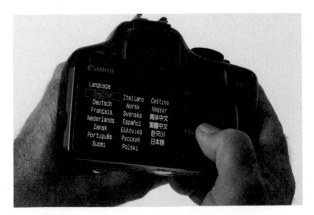

Open the card slot cover and insert a card. The label should be facing you. Push it in until it locks.

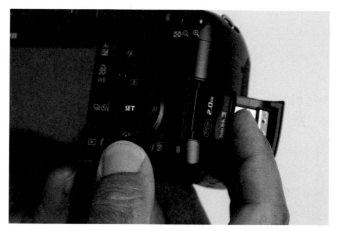

Turn the camera on. The camera will automatically clean the sensor.

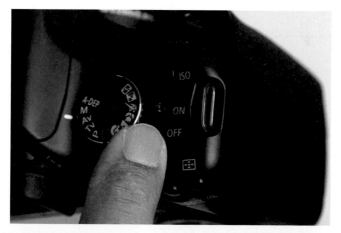

Set the Mode Dial to Full Auto.

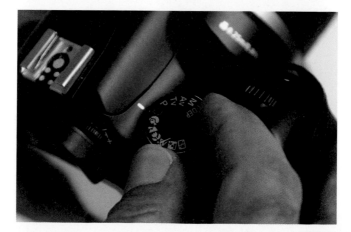

Look through the lens to compose your picture. Press the shutter button halfway to focus.

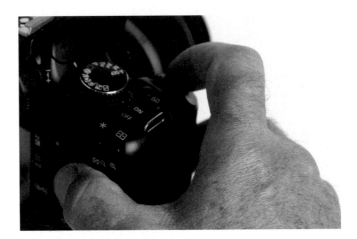

Press the shutter button all the way down to take the picture.

Review the image on the camera's LCD.

Basic Principles of Good Photography

APERTURE AND DEPTH OF FIELD

When we refer to the "aperture" of a lens, we are speaking of an iris, similar to that in the pupil of an eye, that opens or closes to allow light to enter, striking the optic nerve and sending impulses to the brain that are converted to a visual image. A lens aperture works much the same, except it allows as much light to enter as we tell it to allow. Although our brains can automatically compensate for light or dark (a human with good vision is capable of seeing light as dim as a trillionth of a watt), if we tell the aperture to allow too much light for the ISO we've set the chip to record, the result will be an overexposure that the camera cannot compensate for.

A camera's aperture is composed of thin metal blades that, when the shutter is actuated (and at any f-stop other than its widest), move together in less than a blink of an eye to form a circle corresponding to the chosen f-stop. After the chosen shutter speed has expired and the shutter has been closed, they move back to their zero position to wait for the next actuation. Unlike older irises, which were assembled by hand, Canon's are created and assembled robotically, in a super-clean, in-house environment, assuring quality of design, construction, and control.

Throughout this book, you'll see references to "opening up" or "stopping down" your lens. When a lens is opened up, the iris is enlarged, allowing more light to strike the sensor. But, as with so many mysteries of life, things work in reverse; opening up a lens means changing its value to a smaller number. Lenses are rated at their maximum, or fastest, f-stop, thus a lens with a maximum aperture of f1.2 is faster (will gather more light at its maximum aperture) than a lens with a maximum aperture of f2.8. When we shoot "wide open," it means we're shooting at the lens' maximum aperture.

When we stop down a lens, less light strikes the sensor because we change the f-stop to a larger number. F22, for example, allows less light to reach the sensor than f16 because the circle is smaller.

Mathematically, when the aperture is opened up one full stop, the amount of light reaching the chip doubles. For example, changing the aperture from f11 to f8 doubles the amount of light falling on the chip and results in a one-stop overexposure, assuming that f11 would provide a correct exposure.

When the aperture is stopped down one full stop, the amount of light reaching the chip is cut in half. For example, changing the aperture from f11 to f16, assuming that f11 would provide a correct exposure, underexposes the image by one stop.

Shot at −1 stop.

Correct exposure.

One stop overexposed.

The area in front of and in back of the point of focus that appears sharp to our eyes is the image's depth of field. Stopping down the lens increases this area of apparent sharp focus, whereas opening up the lens diminishes it. The closer you are to your subject, and with an opened aperture, the less depth of field. This is useful when you want to isolate a subject against an otherwise cluttered or distracting background.

Shot at f2.8.

Shot at f22, but note how the smaller aperture increased the representation of wind blur.

SHUTTER SPEED

The amount of time a shutter remains open to allow light to strike the camera's sensor is the camera's "shutter speed." A shorter time duration (aka "faster") means more action can be stopped, or frozen. Conversely, slower shutter speeds (aka "longer") allow action to blur. Under many circumstances, longer shutter speeds necessitate smaller apertures, increasing depth of field, but they may result in blurred subjects because the shutter is open for a longer period. This can be an effective creative control.

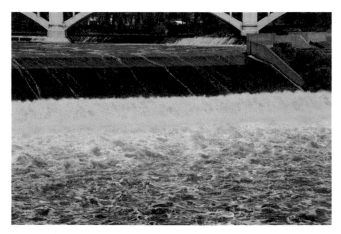

A fast shutter speed freezes rapid motion.

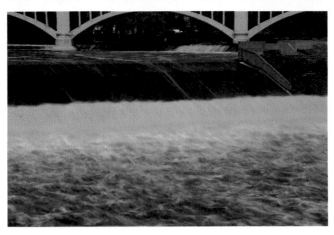

A longer shutter speed, one full second and with neutral density filtration, allowed the motion of the water to create its own design.

When a shutter speed actuation is made slower by the shutter's equivalent of a full stop, the amount of time that light strikes the chip doubles. Change the shutter speed in such a manner without correspondingly adjusting the aperture, and the image will be overexposed by one stop.

When a shutter speed actuation is made faster by the shutter's equivalent of a full stop, the amount of time that light strikes the chip is halved. Changing the shutter speed in this manner without a corresponding change in f-stop will yield an image that is underexposed by one stop.

One stop underexposed.

Correct exposure.

One stop overexposed.

Canon Rebels offer a range of shutter speeds from 30 seconds to 1/4000 of a second. All cameras have provision for Bulb exposures, where the shutter stays open as long as it's depressed. Custom Function (C.Fn.) 1 permits you to choose intermittent shutter speed and aperture increments in $\frac{1}{2}$ stops if you wish (the camera default is $\frac{1}{3}$-stop increments).

RECIPROCITY

Reciprocity is the rule that states that if, beginning with the correct shutter/aperture combination to yield a perfect exposure, the shutter speed is adjusted in one direction (faster, for example) and the aperture is adjusted *correspondingly* in the opposite direction (opened up, for this example), the exposure will be the same.

Let's say a correct exposure for an image is 1/125 at f8. Charting all equivalent shutter speed/f-stop combinations would look like this:

1/15	1/30	1/60	1/125	1/250	1/500	1/1000
f22	f16	f11	f8	f5.6	f4	f2.8

Each combination would yield the same correct exposure. What would change would be the amount of blur in a moving subject (or moving photographer) as the shutter speeds got longer, or the amount of depth of field in the image as the aperture became progressively smaller.

Note that this is a constant rule only when the light source itself is *constant*. Sunlight and most available light are considered constant in that they don't change over the course of the exposure. Fluorescent lights are not considered constant because they flicker on and off 60 times per second. Studio strobes and on-camera flash units are not constant sources of light because they fire and expire somewhere between the time the shutter actually opens and closes, so the amount of light they produce may be figured into the equation (like fill flash) and used to the photographer's advantage to either supplement existing light or overpower it.

Back in the days of film, most of us were trained to think in terms of whole stops and half-stops. In other words, I might have told my assistant to "get me 11 and a half" if I wanted a little more depth of field. Canon's EF Series of lenses, designed for the EOS camera family, easily work in thirds of stops, much more accurate for the touchy digital environment. Similarly, digital cameras have added additional shutter speeds to reflect the additional aperture settings. An expanded version of the reciprocity scale looks like this:

Shutter Speed	1/15	1/20	1/25	1/30	1/40	1/50	1/60	1/80	1/100	
Aperture	f22	f20	f18	f16	f14	f13	f11	f10	f9	
Shutter Speed	1/125	1/160	1/200	1/250	1/320	1/400	1/500	1/640	1/800	1/1000
Aperture	f8	f7.1	f6.3	f5.6	f5	f4.5	f4	f3.5	f3.2	f2.8

Should you decide to set your camera to work in half-stop increments, here's how the reciprocity scale would work for the same 1/125 at f8 exposure:

Shutter Speed	1/15	1/20	1/30	1/45	1/60	1/90	
Aperture	f22	f19	f16	f13	f11	f9.5	
Shutter Speed	1/25	1/180	1/250	1/350	1/500	1/750	1/1000
Aperture	f8	f6.7	f5.6	f4.5	f4	f3.5	f2.8

These are not complete scales, of course. There are lenses with a maximum aperture greater than f2.8 and there are lenses that stop down below f22, but the principle remains the same and can easily be charted for whatever lenses you may own.

Notice, as you look through these images, how depth of field increases as apertures get smaller from f2.8 to f8 to f22.

1/1800 f2.8. Minimal depth of field

1/100, f8. Reciprocal exposure, depth of field increases

1/13, f22. Reciprocal exposure, maximum depth of field.

RESOLUTION AND COMPRESSION

The reproduction quality of any image is ultimately tied to the number of pixels that compose that image. Pixels, shorthand for "picture elements," are present in the millions in all of Canon's cameras, even the company's amateur snapshot cameras, as it takes a million pixels to equal one megapixel. Thus, a 12.2 megapixel sensor contains 12.2 million picture elements, and each element, electrically charged to receive and process information from the light that strikes it, becomes 1/12,200,000 of the final image. The number of pixels that make up an image is the resolution of the image.

Also, the degree of image compression factors in to the quality of the final reproduction. When you look at the resolution settings in the menu of a Canon prosumer camera or Digital Rebel, you will see Large (L), Medium (M), and Small (S) JPEG, all with a Small option, plus RAW by itself and a RAW+ combination that will take a RAW file plus a Large, Medium or Small JPEG at the same time.

The Large JPEG setting will use all of the pixels on the sensor to create the image, whereas the Medium setting uses fewer pixels, and the Small JPEG choice creates an even lower resolution image. You also have a choice of how that JPEG file is compressed. Compression doesn't affect the number of pixels used to make up the image, but how that information is remembered and stored.

Here's one way to visualize what JPEG compression does. Let's say we've chosen to shoot Large resolution JPEGs. When an image is compressed into a JPEG, the processor looks at pixels and their neighbors. If a neighboring pixel is only slightly different than the inspected pixel, the processor remembers the neighbor as the same color. If the degree of compression is low, pixels that may be only slightly different than their neighbors are remembered by the processor as being different and the result is a Large file. If the degree of compression is high, as many pixels as possible are lumped together as the same color, tossing out some detailed information in the name of saving space. The result of high compression is a file that takes up less room on your hard drive or your memory card but may not have the same smooth colors and gradations as a less compressed file. The resolution (or number of pixels) of the file is still the same whether you choose a Large JPEG with low compression or with high compression.

You see, the JPEG file format, as convenient as it is, is what's known as a "lossy" format. The subtle color variation that was there before compression between some of the pixels is gone forever. The same thing happens when the image is recompressed in a program like Photoshop. After a certain number of compressions/decompressions, the image develops "artifacts," areas of color that look chunky because the pixels are not transitioning color or tone correctly. Artifacts are most likely to form around areas of sharp focus against a plain background, such as this chain against a bright sky (see page 22). Once they form, there's nothing that can be done about them, but they're much less likely to be visible in Large files with low compression.

Does this mean that JPEG is a bad format? Not at all. JPEG is a fine format, suitable for almost everything, provided you understand its operation and limitations. Working with JPEGs can be a viable part of your workflow, actually saving you lots of time.

Personally, I believe you should always shoot at a level higher than you'll need. If you are just going to shoot snapshots, with maybe an occasional 8 × 10, I'd recommend

High-quality JPEG.

Low-quality (small) JPEG opened and resaved dozens of
times before artifacts appeared to damage the image.

you shoot Large (Normal). The number of images you can fit onto a card is double that of Large (High) files, yet these files will yield high-quality prints. Pros should always shoot Large (High) JPEG or RAW to get the most out their files.

On the other hand, should you want the versatility of RAW but need a quick reference for an image catalog, you might want to shoot RAW + Small (Normal). It will be easy to use the small JPEGs in Canon's Image Browser or other programs such as iView Media or iPhoto. Use the catalog of JPEGs for reference, then process the images you like from the RAW files. If you're worried about losing important data to artifacts (you shouldn't be), process those images as TIFFs, a lossless format.

> ### TIP
>
> Storage cards are cheap. If you're shooting something important, like a vacation, be sure to have enough cards to cover the trip. If you take a laptop with you, and your machine is capable of burning CDs or DVDs, it's good insurance to burn your files to duplicate disks. Save one with your luggage, and mail the other to your home or office. If your laptop, camera, or luggage is stolen or lost, you'll still have your pictures.
>
> In other words, don't reformat your storage cards until you're sure your images are safely backed up. Yeah, I know. Paranoia is my middle name, but I've never lost anything, either.

The important thing to understand is how compression affects your picture quality. As always, I suggest you test your equipment to determine what makes you happy. Large or not so large, Canon's CMOS sensor technology allows for exceptionally clean data.

COMPOSITION

Good composition will make a mediocre picture better and a great picture terrific. There are a number of "rules" regarding composition that you can use to your advantage. Play with these concepts, and you'll see better images immediately. After a little practice, these principles will become second nature. Bear in mind that none of these rules are sacrosanct—you may readily break them if the image warrants it.

THE RULE OF THIRDS

When you look through the viewfinder, mentally divide what you see into vertical and horizontal thirds. Those lines, and in particular where they intersect, are areas of primary compositional interest. Move your camera or use a zoom lens to place areas of primary interest or action on those lines and intersections. The rule of thirds is the most widely used principle of composition and is as viable for static subjects as it is for people.

Additionally, you can use the lines of the objects in the picture to direct the viewer's eyes in the direction you want them to go. While awake or alive, human eyes rarely stop moving unless daydreaming. Even when looking at a particular item within a picture, a person's eyes will move around the item until the viewer is satisfied that he or she has absorbed all of the pertinent information.

THE HORIZON IN THE LANDSCAPE

Unless there's a compelling reason to do so, the worst place to place a landscape's horizon is in the middle of the frame. In fact, the middle of the frame is just about the worst place to put anything of great interest because it's the most boring section of the

image, compositionally speaking. Place the horizon at either the upper or lower horizontal third for a more visually pleasing image.

THE S CURVE

Look for lines within the subject that form an "S," curving through the image and guiding the viewer's eyes over it. Notice that this image uses the rule of thirds as well, placing the horizon near the upper horizontal third.

With living subjects, you may have to ask your models to move as you wish, or watch carefully until they move into a proper composition. It may take some time for you to develop the sense of timing necessary to shoot on the fly, but trust me, it will happen. One of the great things about digital photography is that images cost you nothing but a little slice of your time.

The Camera

Making Pictures; Viewing
the Images; Menus; Cards,
Readers, and Batteries

Making Pictures

THE BASIC ZONE

Your Digital Rebel offers two options for creative photography, easily accessed via the Mode Dial. The first, the Basic Zone, distinguishes the various functions by icons and can be used "as is" to create great images the very first time you use the camera. Using any of the Basic Zones means the camera will make decisions for you. For first-time users, the Basic Zone is a great place to start.

None of the Basic Zone modes allow changes in white balance, exposure compensation, or exposure beyond what the camera's processor says is correct. Instead, each mode is preset to what a photographer would typically choose for a specific type of image, like a portrait or a landscape. However, if the camera is not able to achieve this effect and get a good exposure, it will still attempt to give you a well-exposed image.

All Basic Zone modes will allow you creative freedom. The Portrait mode, for example, can also be used for landscapes or interiors, although the camera will evaluate the scene with the presets it uses for a portrait. I know this may sound confusing. After all, why go to the trouble of creating six different modes if you can use any of them for any shot? The answer lies in how the camera balances aperture and shutter speed. Understanding how that's done for each mode (and how those balances affect the look of your final image) will help you make great pictures.

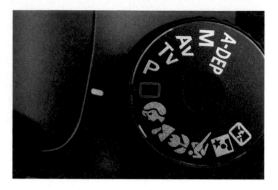

FULL AUTOMATIC

The first zone, strangely enough, is Full Automatic, designated on the Mode Dial as a green rectangle. In Full Auto, you allow the camera to make *every* decision, and you are not allowed to use any function, Custom or otherwise, to change the image. Turning off the "beep" is the only other feature you can use. If snapshot photography is all you're interested in, the Rebel will handle that task beautifully in Full Auto. Unfortunately, you'll also be missing over 90% of the camera's capabilities.

SHOOTING TIP

Someone once told me that it is a good idea to always put the camera away in Full Auto or Program. If you happen to stumble across a "fleeting moment," the camera will be ready to go as fast as it can get ready (.02 seconds), and you'll get an image. This is useful advice for many family situations, as well as for more unexpected situations. In other words, you'll be ready to make tabloid history the next time Elvis appears.

If there's a downside to Full Auto it's that the flash may pop up and fire if the camera thinks there isn't enough light for a good picture (the flash will not pop up if you're using Program). An upside is that the camera will switch back and forth between its One Shot focusing mode (for stationary subjects) and AI Servo (to track moving subjects). The camera will determine if it thinks the subject is moving or standing still.

PORTRAIT MODE

Although you're not limited to using this mode only for shooting people, Portrait mode automatically gives you a fast shutter speed and wide aperture. The fast shutter speed means motion blur (from a moving subject or camera) is minimized or nonexistent. The large aperture provides for minimal depth of field and soft backgrounds.

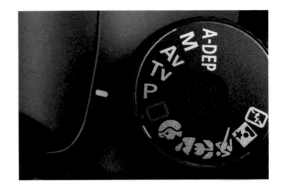

In Portrait mode, the camera defaults to its Multiple Exposure drive. Like motor drives on film cameras, the Rebel will fire continuously, stopping only when the card or the buffer are full. This feature is extremely useful for portraiture in available or ambient light, as people's expressions change over the course of just a second. Shooting multiple frames can capture subtle nuance.

You can increase the subject to background effect by using the longest focal length possible with your zoom lens or by changing to a longer telephoto lens. Moving in closer to the subject will create softer backgrounds.

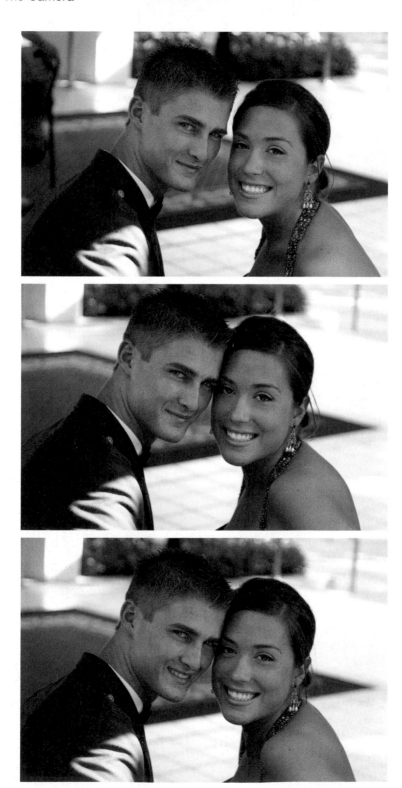

LANDSCAPE

Landscape mode is meant for normal or wide perspective shots of distant horizons. Cameras set in this mode will default to an aperture somewhere in the middle of the lens' range, giving you reasonable depth of field (it's not usually necessary to shoot landscapes for maximum depth of field).

The light meter will default to its Evaluative setting, and the camera will meter the entire scene but give emphasis to the area where the camera has chosen to focus. Should you decide you want to lock your focus and recompose, hold the shutter button halfway down, then reframe and shoot. Landscape mode may be used for interiors, too.

EQUIPMENT TIP

Exposure information will *not* lock or store in the camera's memory unless the shutter button remains half pressed. Also, critical focus is almost never possible in any of the Basic Zone modes because the camera is always set to automatic focus point selection. The camera chooses what it wants to focus on; you don't get to select a focus point to use. Yes, you can focus/meter lock and recompose when in Landscape mode, but which focus point or points the camera decides to use is out of your control.

CLOSEUP

When using the Closeup mode, the camera will tend to choose an aperture that's not quite wide open, like it does in Portrait. The closer you are to your subject, the less depth of field you have, even in Manual mode with small apertures. This mode will give you just a little depth of field to help show-case your subject with more than just pinpoint focus. At the same time, maintaining a faster shutter speed will help eliminate camera shake, which is more obvious when shooting fine detail. Of course, the ability of the camera to focus closely cannot be greater than the closest working distance of the lens.

Should you find you enjoy closeup (macro) photography—and many people do—take a look at Canon's line of macro lenses. The EF 50 mm f2.5 Compact Macro is an inexpensive yet impressive lens to begin with, and it will open up a whole new world for you.

SPORTS

The Digital Rebel's Sports mode attempts to stop whatever action is in front of your lens. In this mode, the camera tries to give you a combination of fast shutter speed to stop action and, whenever possible, an aperture capable of more depth of field than available in Portrait or Closeup modes. Every lens

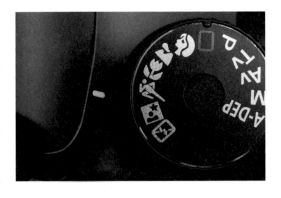

works best at its middle apertures, and the camera will give you those f-stops unless the light level is too low. If that's the case, the camera will set progressively wider apertures to compensate for the low light and to maintain faster shutter speeds. It's only after the camera has reached maximum aperture that it will allow shutter speeds to slow down. Slower shutter speeds, of course, will result in a more blurry image.

The best thing about using this mode is that the camera switches to AI Servo, which can intelligently track moving objects and keep them in focus from frame to frame, even if they're moving toward the camera. High-speed multiple frame shooting is also activated.

To use Sports mode, first place the focusing points on the subject, although you don't need to use the center focus point as the camera

will choose any focus point where there is the best detail and contrast. Next, hold the shutter button halfway down to activate the focus tracking. The camera will beep

softly when it has achieved focus. Fully depress the shutter button to begin shooting, which you can continue to do until either the flash-card or the buffer is full or the action has passed.

NIGHT PORTRAIT

This mode works best if you station your camera on a tri-pod, as the camera will auto-matically hold the shutter open long enough to regis-ter background light behind your subject. It works in tandem with flash, either the built-in camera flash or an accessory unit, and the amount of time the shut-ter stays open depends not on the flash but on the brightness of the background light.

Flash shots typically show a properly exposed subject but a very dark background. This is because the flash loses intensity as it travels away from the subject. For this reason, Night Portrait mode works equally well for inside portraits or in any location where you'd like some detail behind your subject.

Even with a tripod, it's a good idea to ask your subject(s) to hold still after the flash fires and until you hear the shutter close.

FLASH OFF

This mode disables the camera's command to fire the built-in flash or any accessory flash plugged into the flash shoe. The camera attempts to give you a combination of shutter speed and aperture that will properly expose the frame but still provide some depth of field. Under lower light, the shutter must stay open longer, leading to the possibility of camera shake. Based on the focal length of your lens, the shutter speed indicator light, visible inside the viewfinder along the bottom of the viewfinder window or on the exterior LCD panel, will blink to indicate potential camera shake, and you may wish to stabilize the camera with a tripod or other support.

This mode is particularly useful if you need to photograph a building interior and do not want the distraction or influence of a flash. Also, the Auto Focus function will default to AI Focus to enable the camera to switch back and forth between One Shot and AI Servo automatically. This mode is identical to Full Auto (the Green mode), with the exception that the flash will never pop up unless you want to.

THE CREATIVE ZONE

A separate set of functions found on the other half of the Mode Dial, the Creative Zone offers a huge opportunity for aperture and shutter speed options as well as the use of many of the personal or fine-tuning options like custom functions or exposure compensation.

PROGRAM AE

Like its Basic Zone brother, Full Automatic, Program AE (Auto Exposure) is a general-purpose shooting mode and will set shutter speed and aperture in exactly the same way. Still, it offers a number of options that Full Auto does not, and here are a few of the most important:

- You can change the white balance from Auto White Balance to any of the presets or to a custom white balance (always a good idea).
- If your subjects are too light or dark, you may dial in some exposure compensation. This is often necessary when photographing a dark subject against a light background or vice versa.
- The RAW file format is available when using Program AE.
- You can change the Color Space from default sRGB to AdobeRGB (1998).
- All picture styles are available.

TV SHUTTER SPEED PRIORITY AE

Tv (Time value) allows you to choose the shutter speed best suited to your creative needs while the camera chooses the correct reciprocal f-stop. This mode is valuable when you are photographing moving objects because you can easily change the amount of motion blur in your final image, from none at all to as much as you want (if the lighting conditions will support it) and maintain that level even if the scene gets a little lighter or darker.

Note that if you see the aperture light blinking in the viewfinder or on the LCD display, you will not get a correct exposure.

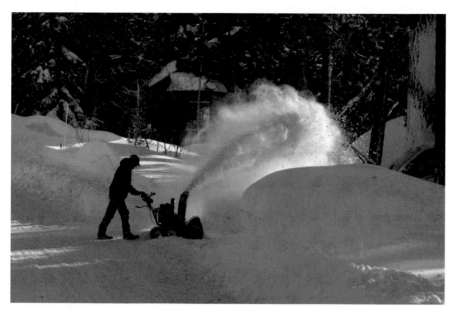

A Tv shutter speed of 1/500 of a second effectively freezes the blown snow.

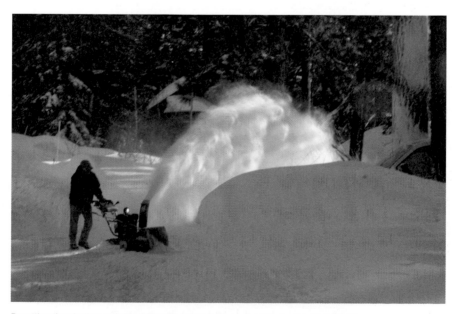

Resetting the shutter speed to 1/25 of a second allows the blown snow to softly blur.

AV APERTURE PRIORITY AE

If depth of field, or the lack of it, is more important than stopping motion, you may wish to use the Av mode. Bearing in mind that a larger number (smaller aperture) will result in more depth of field than a smaller number (larger aperture), use the Main Dial to set the camera's aperture to the desired size and fire away. The camera automatically sets the reciprocal shutter speed. Unless you see the shutter speed number blinking in either the viewfinder or on the LCD, you will get a good exposure.

Personally, Aperture Priority is my favorite mode if I'm just walking around, looking for things to photograph, and just want to snap away. I don't usually like great depth of field, so the faster shutter speeds I get with a large aperture, and Canon's rapid ultrasonic motors and image stabilizers, mean I can shoot quickly and with confidence

under a wide variety of
lighting conditions.

MANUAL PHOTO

Manual is my favorite mode
in the Creative Zone, for a
number of reasons. First
of all, using it forces me to
think about what I'm doing
and what I want to see
when I'm done. If I'm on
location for a commercial
client, I know I can bend the camera to my will and deliver exactly
what the art director wants. And, of course, working in Manual mode
is indispensable in the studio, where everything must be tightly con-
trolled to be successful (and where semi-automatic modes are almost
impossible to work with).

Working in Manual means you will have to set aperture and shut-
ter speed to a combination that will deliver a perfect exposure. In
Manual, you'll use the Main Dial to control both functions, although
the default is shutter speed. To change the aperture, hold down the
Aperture/Exposure Compensation button on the camera's back while
rotating the Main Dial.

You may need to use an accessory light meter when working in Manual under available light. Although you can see light levels measured in the viewfinder, setting the camera this way is somewhat tedious. If your studio is equipped with electronic flash, you will need a separate light meter to measure strobe as well as ambient light.

The Rebel will strobe-sync to shutter speeds as fast as 1/200th of a second. This is often useful if you're balancing strobe light to bright ambient light, either to fill the shadows or to overpower the ambient altogether. You can also attach an accessory Canon Speedlite to the hot shoe on top of the camera or a device such as a Pocket Wizard to wirelessly fire studio strobes.

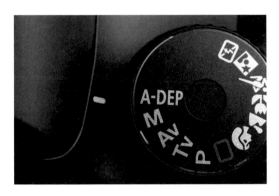

A-DEP PHOTO

There is more depth of field behind an object in focus than there is in front of that object. A-DEP (Automatic Depth of Field) AE uses the Rebel's nine focus points to determine where to place the primary point of focus to achieve maximum depth of field over the area covered by those focus points. A-DEP is especially useful for groups of people or objects set in staggered distances from the camera.

To use it, simply turn the dial to the A-DEP icon and compose your picture. A-DEP will analyze the data from the focus points and set an aperture that will adequately obtain depth of field over the group, along with its corresponding shutter speed. You can see the camera's selection in the information bar along the bottom of the viewfinder or at the top of the LCD display on the back of the camera body.

If you see a blinking shutter speed, either 30″ or 4000, it means the subject is either too dark or too light. If the aperture number blinks, it means that proper depth of field could not be attained. Either move farther away from the subjects or change to a wider-angle (shorter focal length) lens. Also, A-DEP will not work if the lens is set to Manual Focus.

It's possible that with low-light subjects the camera will set a shutter speed that requires a tripod to avoid camera shake.

CHANGING ISO

An ISO number indicates the relationship between the sensitivity of the sensor and the amount of light necessary to render a scene properly. In the days of film, a lower ISO (50, 64, or 100) meant less grain and more contrast but required more light for a correct exposure. Films with a higher ISO number (400, 800, or higher) would produce correct results with more noticeable grain and less contrast, but under darker conditions. Once you put a roll of, say, ISO 400 film in your camera, you were pretty much stuck with it until you finished. With digital, the ISO is tied to the amplification of the sensor, and you can freely change ISO ratings as you shoot.

In the Basic Zone, the Rebel toggles between ISO 100 and ISO 400 as it sees fit (you have no control over its selection). In the Creative Zone, the range is from ISO 100 to 1600, and you can change the range at will.

To change the ISO in any mode in the Creative Zone, press the ISO button (next to the Mode Dial). The LCD will change to the ISO screen. Use the Cross Keys to toggle to the speed of your choice and press the Set key. Your new selection will appear in the upper right corner of the LCD.

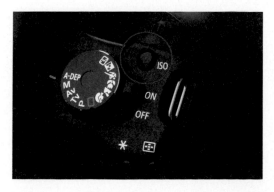

Images made with higher ISOs in earlier cameras were not especially attractive. Signal amplification to the sensor resulted in noticeable "noise," the digital counterpart to film's grain. The Rebel uses new technology that minimizes that noise, resulting in images that are cleaner and more crisp than ever before. This image, for example, was made at ISO 1600 and, although it's difficult to see in this small reproduction, the noise (little that there is) is totally acceptable.

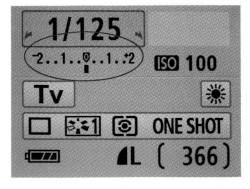

EXPOSURE COMPENSATION

There are times when *any* internal light meter can be fooled, and there will be virtually no way to get an automatic perfect setting from the camera. For example, when photographing a lit subject against an unlit, dark background, the result will often be an overexposed subject. Unless the subject fills the majority of the frame, the

camera will see the large, dark shape and attempt to do its job—to provide an aperture/shutter speed combination that adequately represents the large, dark shape as a properly exposed large, dark shape. In reverse, when photographing a dark subject against a bright background, the camera will underexpose the subject in an attempt to correctly expose the majority of the frame.

You have two options when faced with this challenge:

1. You can take a meter reading with a hand-held meter and set the camera accordingly in Manual mode.

2. You can adjust your P, Tv, Av, or A-DEP exposure through Exposure Compensation.

Exposure compensation forces the camera to give the exposure more or less light than the camera's meter says it needs and is often the only practical solution for exposure problems when shooting JPEGs on the fly. It is also a useful tool if you wish to deliberately over or underexpose for effect, as you will get a consistent adjustment.

To access your exposure compensation feature, press the Av button in any Creative Zone mode and turn the Main Dial to the desired amount.

Practice will teach you the correct levels of exposure compensation for a variety of situations. When dealing with constants, such as shooting a snow scene, you may find that compensation of +1 stop over what the camera says will give you perfect results every time.

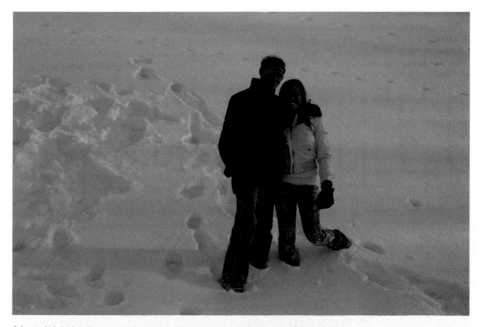

A large bright background may cause the camera to underexpose the subject.

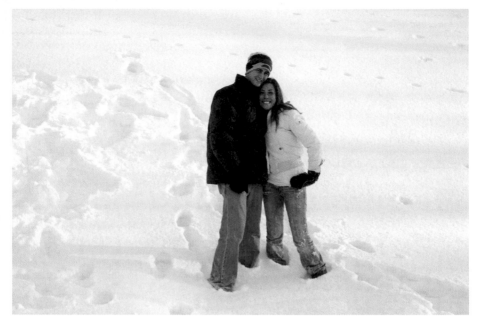

An exposure compensation of +1 stop forces the camera to add more exposure to the scene.

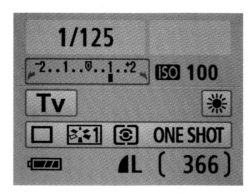

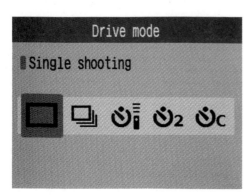

Exposure compensation may be acquired in $\frac{1}{3}$-stop increments ($\frac{1}{2}$ stops when CFn 1:1 is used), up to two full stops plus or minus. To activate the function in P, Tv, Av or A-DEP, simply depress the Aperture/Exposure Compensation button while turning the Main Dial. You'll see the compensation amount change on the LCD screen.

Exposure compensation changes stay in place even if the camera is turned off. You'll need to manually reset to zero when you're finished.

DRIVE MODES

The Rebel provides three different ways to work the shutter, all of which are accessed through the Drive Mode Selection button found on the camera's back next to the LCD screen. Push

that button and the Drive Mode screen will come up on the LCD. Use the Cross Keys to make your selection and press the Set key. Note that Drive Mode selection is not an option in the Basic Zone.

SINGLE SHOT

Just as it says, this function allows only one frame per shutter depression. This is the default setting, and it is perfect for everything that doesn't move.

CONTINUOUS SHOOTING

You can shoot approximately 3.5 frames per second, continuously until either the buffer or the card is full. Many people never consider this mode, and I don't know why. Perhaps they feel looking through the extra images will be too much work, perhaps it's because they don't attach enough importance to the subject. Whatever the reason, the continuous shooting option should not be overlooked. The additional frames will show subtleties that increase your odds of getting a great image instead of just a good one.

SELF-TIMER

Want to be your own star? Using the first self-timer option gives you 10 seconds to get in front of your own lens and create a masterpiece. With the self-timer selected, push the shutter button. The Self-Timer Lamp will flash and the camera will beep in half-second intervals for the first 8 seconds, steadily for the last 2 seconds.

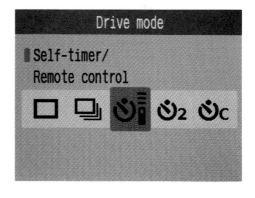

When 10 seconds is just too long to wait, you may select a 2- second delay instead. This is especially useful if you're using C.Fn-9, Mirror lockup (see Custom Functions) to take a picture that might be affected by camera shake, such as a time exposure. When your image is composed, depress the shutter once to lock up the mirror and once more to take the picture. You have 2 seconds to get your finger off the camera before it fires.

New to the XSi/450 is the option to self-time a continuous burst of up to 10 frames. To use this feature, select the "C" option and use the vertical Cross Keys to set the desired number of exposures. Press Set. When you depress the shutter, you'll hear the 10-second countdown beeps after which the camera will capture the continuous sequence.

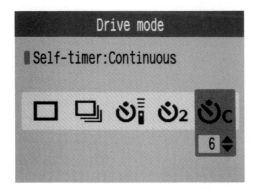

Please note that the camera will auto focus as you depress the shutter. If you'll be standing beside a person or an object, you shouldn't have a focus problem. If not, you'll need to disable auto focus and manually prefocus on the spot where you'll be. Those of you using C.Fn-10, back-button focus, will also need to prefocus.

EXPOSURE AND METERING
AVAILABLE METERING MODES

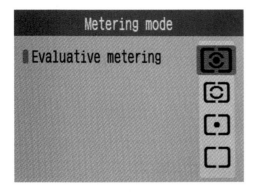

The Rebel's internal light meter is the instrument that measures the brightness of the subject and, in all but Manual mode, sets the camera's shutter or aperture to what it sees. Rebels are capable of metering exposure, via TTL (Through The Lens) full aperture metering, four different ways, each of which is accessed though the Metering Mode button located on the top of the Cross Keys. Whether you select Evaluative, Partial, or Center-Weighted Averaging, you'll get an accurate exposure for any "average" scene.

Understanding, in visual terms, what each mode might do for you is crucial to your development as a digital photographer. After all, what's the use of buying this beautiful technology if you never use anything but Program or Full Auto?

Evaluative Metering is the most general purpose metering system and is the default mode for all of the Basic Zone settings. It is a sophisticated system based on zones of varying selectivity, with the most important zone located around the center focus point. It is considered to be the best mode for most scenes.

If your scene features a subject that is darker or lighter than the background, you may get more successful results by selecting Partial Metering. The area measured by the meter is about 9% of the total frame, in the center. Essentially an oversized spot meter, Partial Metering can be utilized when a dark subject needs to be balanced against a brighter one or vice versa.

Because there were more bright areas than dark, the Evaluative mode slightly underexposed this image.

The Partial mode effectively balanced the bright wall and dark window.

For more precise measurements, select the Spot Meter, which reads approximately 3% of the frame. This selection can be valuable when photographing backlit objects or when you require critical exposure of a small portion of the scene. Canon considers this a mode for "advanced" users, but don't let that stop you from playing with it. It's not that difficult to master.

The Spot Meter did a perfect job of metering the center of this image, but because the area it read was mostly dark, the image is slightly overexposed.

The fourth method is the Center-Weighted Averaging Meter, which takes the majority of its reading from approximately 25% of the frame, from the center, then averages that portion against what it reads from the rest of the frame. This function is valuable when you are photographing an object or group that is more important than the surroundings but not significantly brighter or darker than those surroundings.

The Center-Weighted Average Meter balanced both the brights and the darks for this image.

AUTO FOCUS

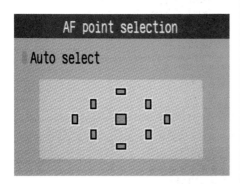

When you look at a potential photo op, the first thing you see is usually the most important element. You've trained your eye to see the important details and to tell you how to compose the image. Let's see how Canon can help you capture that vision, beginning with some of the options you have for focusing (and I want to qualify "some of the options") because you can create personalized control combinations tailored to your special shooting needs using specific controls and Custom Functions.

Canon's wonderful auto focus system is, in my opinion, the top of the line. Designed entirely in-house and refined during the 35 mm EOS era, new algorithms and new chip technologies have increased performance to an auto focus mechanism of unparalleled performance.

Working in conjunction with the super fast Digic III processor, Image Stabilization (in some lenses), Ultrasonic Motors, and the latest in CMOS imaging sensor upgrades, Canon's auto focus mechanics are something for the company to be proud of and for you to exploit as just one more tool to make your photographic life easier.

To be effective, any auto focus system must know where to look. The Rebel's system uses a combination of one high-precision cross-type sensor along with a network of eight single-line sensors within the frame for an accurate focusing mechanism. Using Canon's auto focus (AF) technology and certain Custom Functions allows you to tailor your focusing habits to your camera, to your application, and, ultimately, to the success of your images. Canon's AF technology permits you to achieve fine focus by allowing the camera to select the area it believes is dominant (it's usually correct) or critical focus by manually selecting the AF point you wish to use.

You can see the Rebel's AF points when you look into the viewfinder. To access them for selection, press the AF Point Selector button located in the upper right corner of the camera's back (this button is also used to enlarge images in Playback mode). Use the Main Dial to rotate through the selections (also visible on the LCD) until you select the individual AF point you wish or, when all the lights are lit, use

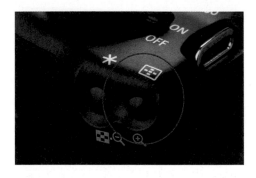

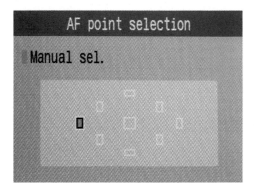

Automatic Focus Point Selection (AFPS). You will have approximately 5 seconds to rotate the Main Dial, after which AF point selection will turn itself off. After you've made your selection, aim the camera at your subject and hold the shutter button halfway down. In the viewfinder, you'll be able to see how your camera has evaluated the scene and where it has decided to focus.

Should you decide you don't like the AF points the camera chose or if the area you wish to be sharp is outside the AF points, you may move the camera to a better position, push the shutter button halfway to achieve focus, then recompose the image without releasing the shutter button.

Some situations may require shot-to-shot focus in a particular area, perhaps a series of portraits in which the subject's face is too far off center to effectively utilize the entire focusing matrix. In this circumstance, you can simply use the AF button to select a single focus point that's appropriate to your composition.

AE LOCK

AE Lock works only in the Creative Zone, but not in the Manual mode.

When you need to have a certain portion of your image metered properly yet wish to compose the image for a different area, you can use AE (Auto Exposure) Lock to lock the exposure for the important area in place while you shoot around it.

The AE Lock button is located on the back of the camera,

on the upper right side. This is the same button you will use for FE (Flash Exposure) Lock as well as FEL (Flash Exposure Lock) focus. I think it's best to assign a focus point before using this AE Lock, as the reading will be more precise than if you used Automatic Focus Point Selection (AFPS), and I'd suggest the center just because it is a high precision cross-type point. If you use FEL Focus (back-button focus), you must disable this feature before using AE Lock as focus must be achieved through the shutter release.

To use this function, place the focus point (the center, in this case) on the part of the image you wish to be correctly exposed. Press the shutter halfway to achieve focus. Immediately press the AE Lock button and keep it depressed. Recompose the image and shoot. You may recompose and shoot as many pictures as you like with that exposure, as long as you hold down the AE Lock button.

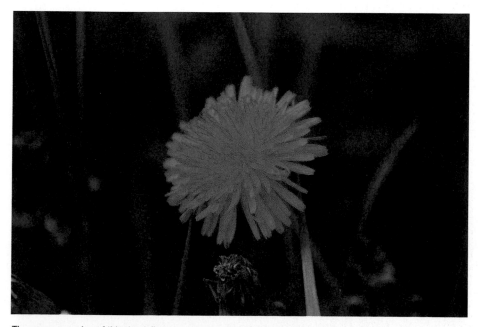

The exposure value of this dandelion was measured with the center AF point.

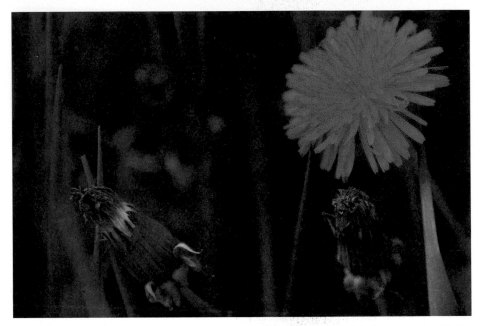

Once the value was determined, the shutter was held halfway and the AE Lock button engaged while the image was recomposed. If the photographer had not used the AE Lock button, the meter would have read the darker center and overexposed the dandelion.

AUTO FOCUS MODES

To use any auto focus mode, you must set the Focus Mode switch of the lens to AF (you can always focus manually when this switch is set to M). You cannot switch between modes if the camera is set to Full Auto, although you can switch between One Shot, AI Servo, and AI Focus when in Program mode. You can also change your focus points, something you cannot do when you're in Full Auto or any other Basic Zone.

Three auto focus modes are available on the Rebel, accessed by pushing the AF button on the right side of the Cross Keys. Make your selection based on what you are shooting, and press the Set key to enable it.

ONE-SHOT AF

Of the auto focus modes available on Canon gear, One-Shot AF is most suitable for any subject standing still. With Automatic Focus Point selection, the AF point that the camera uses to determine focus will flash briefly in the viewfinder, giving you an opportunity to judge whether or not the critical focus area was selected. A

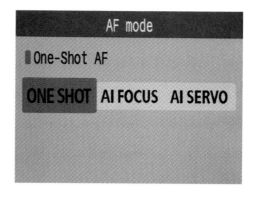

Focus Confirmation light will be displayed in the viewfinder at the right end of the info bar.

If focus cannot be achieved, the Focus Confirmation light will blink rapidly. This can sometimes happen even if you're working within the focusing limits of the lens. Areas of flat or minimal detail, like a blank wall, or reflective surfaces like mirrors or windows may send the auto focus mechanism into a sort of subelectronic dilemma, racking the lens through a complete focusing cycle that finds nothing to lock on to. It can be frustrating when it happens, but it won't hurt anything. Practice with the camera will minimize these episodes.

With One-Shot AF and Evaluative metering, and with Aperture Priority or Shutter Priority selected, the aperture or shutter speed are

set at the same time that focus is achieved and will be locked as long as the shutter button is depressed halfway. This allows you to recompose the shot, if necessary, without changing the light meter reading, a useful tool if you'd like to zoom in on an important detail, meter it, then zoom out for the actual exposure.

AI SERVO AF

There's no question that Canon's auto focus is blazing fast and deadly accurate. It's always been one of Canon's better features, and as such it is always under improvement. It seems that each new model works faster (and under progressively lower light levels, too).

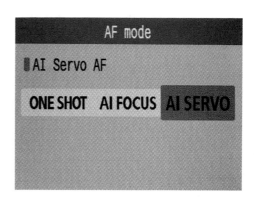

After selecting AI Servo from the Auto Focus options button, start by holding the shutter button halfway down to get the first focus point on your subject, then simply continue to hold the shutter button in the same position, halfway down, for all the exposures in your series. If you let up on the shutter button, you will have to acquire a starting auto focus point before the AI Servo will kick in again. Note that neither focus confirmation lights nor beepers will be visible or audible in this mode.

Canon has also built in what the company calls Predictive AF, a function within the AI Servo that allows the camera to analyze the movement of objects as they approach or retreat the camera at a constant rate. If you manually select an AF point, the camera will track the

subject and will predict and confirm that focus point immediately before making the exposure. If your AF point selection is automatic, the camera will use the center AF point to begin but continue to track the subject as long as it is covered by at least one other AF point within the focusing ellipse. In this case, any active AF point will not light up. Trust it. It works.

AI FOCUS

AI Focus is a nifty little feature that combines the best of One-Shot Focus and AI Servo.

When AI Focus is selected, you can shoot as you would with subjects that are not moving, or moving minimally, essentially One-Shot focusing. Should the subject begin to move with more energy, the camera will

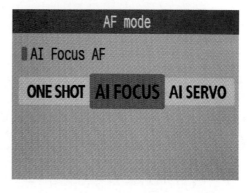

automatically shift into AI Servo mode, tracking and predicting the next point of focus. This feature works just as well if the photographer moves toward the subject.

Using AI Focus does not require you to hold the shutter button halfway down during the sequence, it will reacquire focus frame to frame, much more rapidly than if you were using One-Shot Focus.

At first glance, it would appear that AI Focus is the way to go. After all, an auto focus program that will track both moving and nonmoving subjects should be pretty cool, right? If there is a problem with AI Focus it would be that the camera has to make some complicated decisions in an extremely short period of time. I'm here to tell you, at least for this technological moment, that doing so is a tough job. Personally, I've seen this function succeed and fail, for a number of reasons, not the least of which was that both the subject and I were moving. AI Focus can sometimes mistake a slow-moving subject for stationery or, because it has many decisions to make, can miss a fast-moving object.

Test this for yourself. I'm sure that with just a little practice you'll know a whole lot more about how Canon's AF system works.

I've noticed in lower light situations, such as when a subject is lit by a relatively dim softbox in a studio, and when using the shutter

button to focus, it will take a bit longer for the lens to achieve focus. There is a Custom Function (C.FnIII-10), "Shutter Button/AE Lock Button," that uses the AE-Lock button (also known as Thumb Focus, Rear Button Focus, or FEL (Focus Exposure Lock) Focus, to act as the AF activator.

Wedding photographers, sports photographers, and photojournalists love this feature, because they can focus, and change focus, using a thumb. When an index finger is only used to make the exposure, it means that focus can be achieved, held, or changed without waiting for the shutter button to find it. If focus is made in this manner, the actual exposure will be made faster than if the shutter button AF mechanism had to be activated before making the exposure. Also, when AI Servo is engaged, focus is continuous, as is the ability of the shutter button to shoot, which means you could change the plane of focus during a burst or suspend AI Servo while waiting for your subject to clear a visual obstacle, reacquiring focus when you can and starting a new sequence. It may take a little practice, but once your thumb and forefinger learn to work together you'll appreciate the fractions of seconds this technique adds to your timing skills.

As with most Custom Functions, there is more than one way to use it. Option 2 is terrific for sports photographers or anyone who may pre-focus on a spot and wait for the action to get there. Option 2 will start the AF function on the shutter button but let the photographer suspend that command by pressing the AE Lock (rear button), effectively locking focus on the predetermined point. I think you will find this option is most useful when exposure is set manually, as subjects entering the frame may skew the exposure value when either Av or Tv is set.

When Option 3 and Rear Button Focus is selected and you're using Av or Tv for exposure, there is no Auto Exposure lock, so if you're following a moving subject through changing light conditions, the camera will adjust automatically to the changing light.

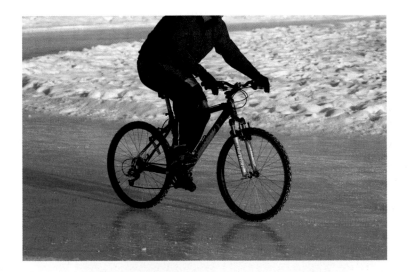

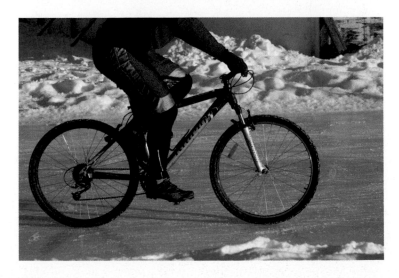

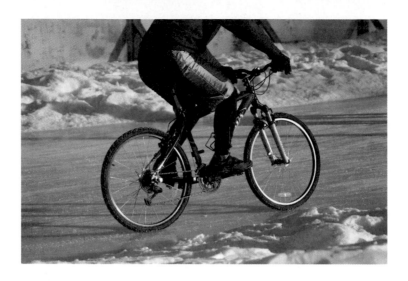

MANUAL FOCUS POINT SELECTION (MFPS)

You may find it helpful to select a focus point manually. This is a useful function if you have many shots where the primary focus point will fall in a specific area, such as with a series of head and shoulder

portraits. In such a case, you will not want the focus point to be influenced by body parts or props; you'll want to keep primary focus on the subject. Whether you're shooting vertically or horizontally, you can select the proper focus point by pushing the AF button and selecting the correct focus point using the Main Dial as previously noted. As long as your primary focus area falls under this focus point, your subject will be in focus.

WHITE BALANCE AND COLOR SPACE
COLOR TEMPERATURE

Although light may look white to your eyes, the camera may not see it as white. White light is a mixture of all colors and varies in its mix from situation to situation. Our brains have been trained to automatically neutralize the mix, and we see white as white almost all the time. Unfortunately, no camera is able to do that 100% of the time, and we must set the camera so it can correctly interpret the intrinsic color of any scene as neutral.

Technically, color temperature is expressed in degrees Kelvin (usually noted simply as "K") and is based on the color of light emitted by a heated bar of pure iron. Daylight, as measured at high noon, is averaged at 5200 K in the Canon system. This means that images made with a Canon that has been preset to Daylight will interpret whatever you shoot as though 5200 K was correct and neutral for that scene. Images made with the Daylight setting but shot under warmer light (less than 5200 K) will have a red/yellow (warm) color cast, whereas images made in light with a higher color temperature will carry a bluish (cool) cast. Using a preset adds a predetermined amount of color to balance your "guesstimated" color temperature to daylight, 5200 K.

WHITE BALANCE

The Rebel has a selection of seven white balance presets plus a Custom White Balance (CWB) that you can measure yourself. Daylight uses Canon's default color temperature of 5200 K; Shade works at 7000 K; Cloudy at 6000 K; Tungsten/ Incandescent at 3200 K; White Fluorescent is set to 4000 K (although there are huge color temperature variations in fluorescent lights); Flash at 6000 K.

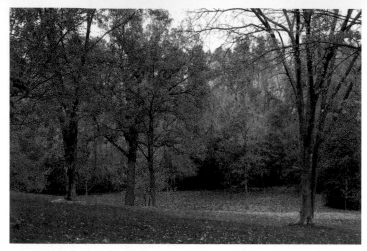

Auto White Balance.

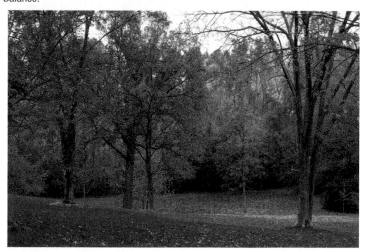

The same scene using the Daylight preset.

Using the Shade preset.

The Cloudy preset splits the difference between Daylight and Shade.

The Tungsten preset cools the image dramatically because it presumed the image was warmer than it was.

Using the Fluorescent preset.

Flash uses the same color temperature as Cloudy.

Custom is the most accurate white balance.

Auto White Balance (AWB) attempts to neutralize the light of any scene with a color temperature between 2000 and 10000 K, but it can be fooled. If there is an overriding color tone in the background or foreground, the camera may see that as a color temperature that needs to be neutralized. The resulting image may not be as neutral as you'd like it to be.

Auto White Balance (AWB) tries to balance the strong background and clothing color against skin tones to create a true neutral but cannot do so.

Custom White Balance (CWB) doesn't care what colors make up the image, only the color of the light that falls upon it.

CUSTOM WHITE BALANCE (CWB)

Making a CWB is easy with the Rebel (it will even remind you to change the preset if your camera is set for something else). To do this effectively, you will need to meter and photograph a neutral gray or white card under the light conditions within the frame. If you're working under studio strobes, you will need to use a calibrated flash meter to accurately measure the strength of the light. Either way, it's important to purchase a neutral target. Typewriter paper, tablecloths, bridal gowns, or other objects contain chemicals or bluing agents that make them *look* neutral, but they will not white balance properly because of that chemistry. A commercially available gray target, such as those sold by Lastolite or BalanceSmarter, will produce the most accurate white balance.

	DISP.
AEB	-1..0..1..2.:3
Flash exp comp	-2.1..0..1.:2
Custom WB	
WB SHIFT/BKT	0, 0/±0
Color space	Adobe RGB
Picture Style	User Def. 1
Dust Delete Data	

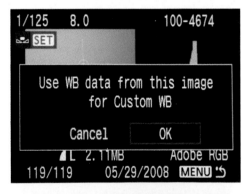

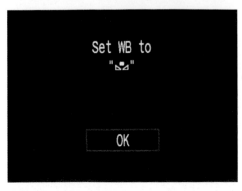

Err on the side of caution and fill as much of the frame as you can with the gray target. It's not necessary for the image to be in focus, although a target like this BalanceSmarter, with its printed lines, is helpful because you won't have to disable auto focus to make the shot.

In the Shooting menu choose Custom WB. You will be asked to select an image, but the camera always defaults selection to the last image made. If you're happy with that image, press the Set button.

If your White Balance icon is not already set to Custom, you will be told to set it accordingly. You're now good to go.

FLASH
USING THE BUILT-IN FLASH

Working with the built-in on-camera flash is terrific for snap-shots, although the tube is small and produces a bright, specular source that will accent skin shine and show dark (although minimal) shadows. The flash is placed close to the lens and pops up vertically just above the lens axis. Although this guarantees even light over its effective working area, the look of the images will actually be flat. It's best, in my opinion, to use the built-in flash only for horizontal compositions. If you turn the camera to its vertical position, the resulting shadows will fall straight across that axis and look unattractive. That said, the built-in flash can be effective as fill flash, a little something to brighten up a shot without overpowering it.

Flash Exposure Compensation is a function on any Canon with a built-in flash. It allows an increase or decrease in the flash output power relative to what the camera tells the flash it needs, a determination the camera will make based on the light at hand and the shooting mode it's in. You are allowed up to two full stops of exposure compensation, over or under what the camera considers to be correct, when you use this function.

We all know that outdoor exposures, even made under diffused daylight conditions, can show shadows that are not especially attractive even though the subject may be. If a face is lit from the side, for example, eyes tend to look lifeless because there is no catchlight, no hint of a light source, to give them a spark.

Without fill flash.

Even if the camera does not automatically raise the flash (there may be so much light that the camera won't think it's necessary), push the flash button near the lens and pop it up manually.

Without making any Flash Exposure Compensation, the camera will use the built-in flash as a

fill flash. Comparing a noncompensated image with one deliberately set to $-\frac{1}{3}$ stop would indicate that this is the camera's default fill flash position.

Rebel's default fill flash ratio.

Flash Exposure Compensation $-\frac{1}{3}$ stop.

With further compensation adjustments, at $-\frac{2}{3}$, -1 and -2 stops, you can easily see how Flash Exposure Compensation can improve your images when used as a supplemental light source. In each case, look at how much life the catchlights in the eyes add to the shots.

Compensation $-^2/_3$ stop.

Compensation -1 stop.

When working with built-in flash indoors, there are a couple of things for you to consider in order to improve the quality of your images. Use a shooting mode that will take ambient light into account. If you use Manual, be sure to set a shutter speed and aperture that will include enough ambient detail to show the background. A shutter speed that's too short or an aperture that's too small will not allow enough ambient light to register, resulting in dark backgrounds with minimal or no detail. Even though the exposure from the flash will

Compensation −2 stops.

be terrific, the lack of ambient detail will result in "tonal merger," a part of the image where dark areas of the subject like hair or clothing are so dark they become indistinguishable against the background. Photos made with tonal merger lack the three-dimensional quality that makes for a better shot.

Watch for areas where dark objects blend into background shadows.

You'll get better results working in a mode that supports ambient light exposures. On the Basic side of the dial, Portrait, even Night Portrait, will produce great results because the exposure will be made for both ambient and flash. On the Creative side, Av, Tv, even A-DEP will produce nicely lit, dimensional results that balance ambient light to the flash.

Increasing the amount of ambient light exposure decreases the possibility of tonal merger.

Viewing the Images

ON SCREEN PLAYBACK

You're not limited to reviewing images one at a time on the LCD screen. The Rebel provides a number of options for your viewing pleasure. Of course, if one at a time is right for you, just push the Playback button to view the last image made. Use the left and right Cross Keys to toggle back and forth through all images on the card.

IMAGE MAGNIFICATION

You can zoom, up to 10X, into any picture on the Playback screen by pressing the Magnify button in the upper right corner of the camera back. Use the Cross Keys to navigate through the

image. Press the Reduce button (aka the FEL button) to reduce the level of magnification.

You can spin the main dial to view the next or previous image and maintain the level of magnification. To leave the Playback screen, just press the Playback button again.

REVIEWING MULTIPLE IMAGES

If you're looking for a particular image and want to see a more encompassing selection, push the Index button (same as the FEL button) and the screen will show the last four images. Push the Index button again, and the selection changes to nine images. The image that came up first will be highlighted with a blue box. Use all four of the Cross Keys to maneuver through the group.

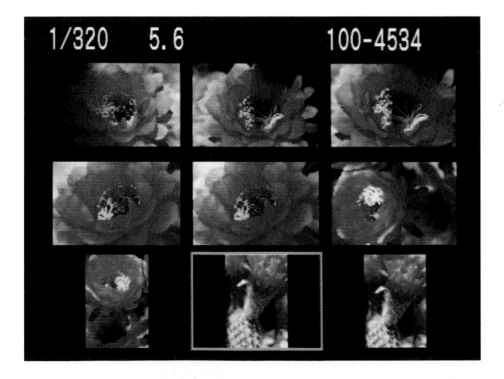

When you arrive at an image you'd like to see, use the Magnify button until your selection fills the LCD. If you'd like to see more of that image, use the Magnify button to zoom into the image. To return to the group selection, use the Index button (which now functions as a Reduce button) to reduce the magnified image until it once again becomes part of the group.

Should you wish to see the next batch of four or nine images, use the Main Dial to move the selection forward or backward.

JUMPING

When you have many images on a card, especially if there are many shots of a similar subject, you may wish to get through them a bit faster. "Jumping" is an option by which you can bypass images in groups of 10 or 100 (even single images) using the Main Dial.

With the Playback button engaged and only one image on the LCD, push the top Cross Key to reveal the Jump menu. Continue to push the top Cross Key until you get the number you want, or push the bottom Cross Key to go back, then push Set. Use the Main Dial to work your way through the card. The progress bar for the function will give you an approximate idea where the selection is relevant to the number of images on the card.

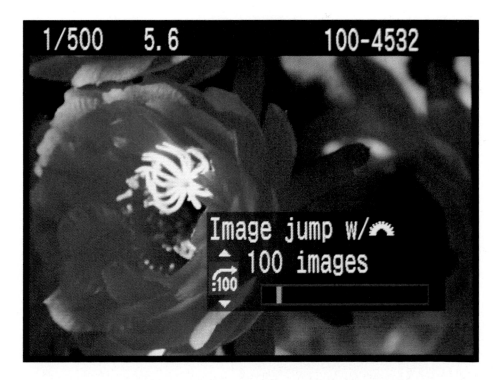

Use the Reduce and Magnify buttons as before. When you get into the group you wanted, use the side Cross Keys to refine your search.

AUTO PLAYBACK

See Menus>Playback Menu>Auto Playback for instructions on this feature.

IMAGES ON TELEVISION

If the Playback screen isn't big enough for you, use the included video cable to play your images back through your television. With both the television and the camera turned off (important!), use the cable to connect the camera's Video Out terminal to the television's Video In.

Turn the television on and set the Line Input to Video In and power up the camera. Press the Playback button, and your images will appear on the TV screen. Don't forget the popcorn.

Menus

The Digital Rebel's three menu categories are distinguished by color. Shooting menus, indicated in red, tell the camera how it should interpret what it sees to create the correct file. The blue Playback menu offers options that tell the camera how you want to see what you've shot, whereas the yellow Setup menus allow deep customization of the camera's operations.

Menu choices are limited for Basic Zone operation and expand to their full potential for all Creative Zone applications. This text examines all options as though the Creative Zone was in play.

SHOOTING MENU 1

Quality The Rebel provides eight choices for image compression, each of which can deliver a quality image. The primary difference between them is that file sizes will be smaller with settings of lesser quality,

Quality	L
Red-eye On/Off	Off
Beep	On
Shoot w/o card	On
Review time	Hold

which means your enlargement opportunities become more limited as file size is decreased. Personally, I think you should always shoot at the highest level of quality, even though larger files will deplete card storage space more rapidly, but it ultimately depends on what your output will be used for. Folks who shoot strictly for Web-based applications have little use for a full-sized file.

You may also select the RAW option. RAW files represent all the information in an image, and they are like digital negatives. Unlike any of the JPEG selections, wherein the camera makes decisions, you must process RAW files using Canon's Digital Photo Professional software (supplied at no charge with the camera) or a third-party RAW converter.

You may also shoot both RAW and Large (aka High) JPEGs at the same time. This may be a useful option for you if you can get the image quality you want out of JPEG but want the option of fixing an image that may not be quite right. Frankly, if you're new to digital photography, this combination is a great way to learn the camera and mess up as little as possible. I'd suggest you shoot both RAW and Large JPEG at the same time. This will burn up card storage space faster than JPEG

This is the Large JPEG image as the camera processed it.

alone, but it will let you compare the two identical files in Canon's file browser. If you like the JPEG, trash the RAW file. When you're making prints, there is almost no difference in the quality between an "as is" processed RAW file and a perfectly exposed JPEG.

The RAW file processed "as is."

TECH TIP

Whether you're going to make large prints yourself or send the files off to a lab, it's probably best not to resize them beyond what you can do when converting a RAW file. Photoshop's interpolation software, though adequate, is only a small portion of the entire program and shouldn't be expected to do an A+ job.

Labs use RIP software, programs designed specifically to interpolate imagery, which are much more accurate than what's generally available to us. True, we can purchase RIP software from third-party manufacturers, which we should if our equipment is going to the do the work, but it's expensive. I think the expense is justified if the burden is on us; otherwise, let the lab resize the images (be sure to ask your lab how it will interpolate your image, of course).

Red-Eye On/Off Anytime a flash tube fires close to the lens axis and in a low-light environment, you run the risk of red-eye because the flash enters the eye through the enlarged pupil and illuminates the back of the eye, showing red. It's never attractive, but neither is a portrait of a face with huge pupils. Red-eye reduction is possible in any Basic Zone except Landscape, Sports, and Flash Off. Red-eye reduction is possible in any Creative Zone, but you must manually push the Flash button, as the flash will not automatically pop up in dim light.

SHOOTING TIP

Look in the viewfinder, just below the Exposure Compensation scale just after the reduction preflashes have fired. You'll see a series of vertical bars that begin to disappear from the sides toward the center. This represents the average amount of time it takes human pupils to respond to the preflashes. Make the actual exposure when all the bars disappear.

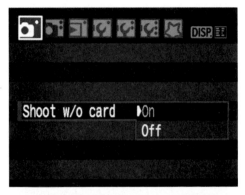

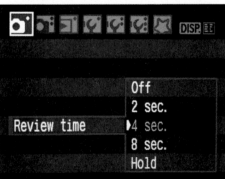

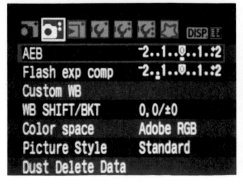

Beep This feature controls the camera's audible signal. You can turn the signal off in any situation where noise would be a distraction.

Shoot w/o Card This feature let's you preview an image or test a function without writing an image to a card. Don't forget to load the card before the "Moment of Truth."

Review Time You can change the amount of time the image will be viewable from none at all (Off) to always on (Hold).

SHOOTING MENU 2

AEB Auto Exposure Bracketing is useful for those moments when you're not sure you'll get the correct exposure, no matter how carefully you check it. To use this feature, select AEB and press the Set key. Use the Cross Keys to select the exposure spread and press Set again. Because you must press the shutter button three times, a tripod or other support is a good idea.

AEB will continue to function until deactivated, and the easiest way to do this is to turn off the camera briefly. Otherwise

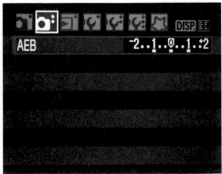

simply select AEB in the menu, press Set, and dial the compensation amount back to zero.

The camera default is in $\frac{1}{3}$-stop increments, up to $+/-2$ stops. C.Fn-6:1 will deliver compensation in half stops.

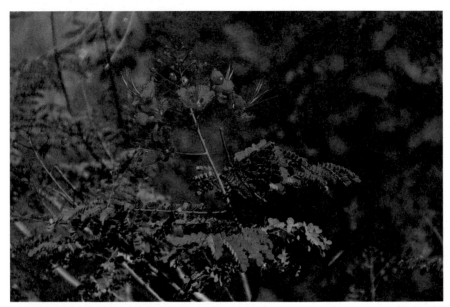

AEB's first shot will be the low end of your selection.

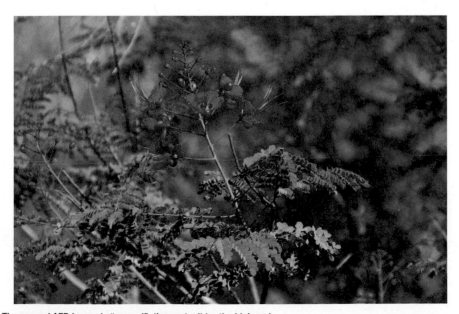

The second AEB image is "normal", the next wil be the high end.

Flash Exposure Compensation Flash Exposure Compensation is useful when you are shooting under stable conditions and wish to change the amount of fill flash reaching your subject or when shooting under conditions that would ordinarily fool the flash, such as a light object on a dark background. Like AEB, it's adjustable in $^1/_3$- or $^1/_2$-stop increments. (See p. 71 for a detailed explanation of fill flash techniques, see Flash for equipment options.)

Without any flash fill.

Flash fill at $-\frac{1}{3}$ stop. Notice how much life the extra light adds to the shot.

WB Shift/BKT Similar to Auto Exposure Bracketing, White Balance Shift/Bracket can produce from one to three color variations from a single exposure. It's an interesting feature because you don't need to shoot a complete bracket set. If you routinely like your images a little warmer or cooler, or a little more yellow or green, you can set the screen where you wish. From the moment the feature is engaged, all of your images will exhibit the color change, regardless of which White Balance mode you are in, including Custom White Balance.

To access this feature, open the menu and select WB Shift/ Bracket. Entering that screen will get you what is, essentially, a color chart that you can navigate through to select either a Blue/Amber or Magenta/Green bias. If you want a WB shift to affect every image, use the Cross Keys to maneuver the mark. Want groups of three? Turn the Main Dial clockwise to spread the mark horizontally for a Blue/Amber shift, counterclockwise to move it vertically for a Magenta/Green shift. Press Set to engage. The Rebel will create three frames with the WB Shift for every actuation of the shutter. This feature will remain engaged until you move the mark back to the middle position or turn off the camera.

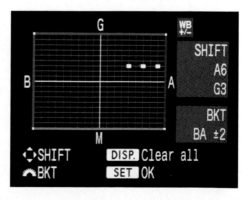

What the camera produced from the left marker.

The middle marker.

The far right marker produced the warmest image.

Custom WB As discussed earlier in this chapter (see White Balance for complete details), a custom white balance will always produce the most unbiased, neutral color.

A gray target shot under "bad" light.

The same card in the same light after a Custom White Balance.

Color Space Here's where you select either AdobeRGB (1998) or the sRGB color space. As previously discussed, the final reproduction method for your images will determine which color space you should use.

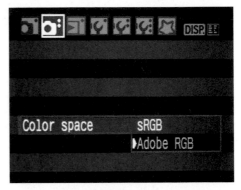

Picture Style Canon has developed a number of fantastic algorithms that add emphasis to various aspects of your images by changing how the camera sees color and further manipulating sharpness, contrast, saturation, and color tone. Standard, my favorite, gives me vivid, saturated colors. I like it, even for most portraiture, because the results look slightly larger than life. I would encourage you to experiment with each Picture Style in the same way I did with the few samples I have room to include here. You may find your favorite to be different from mine.

Standard Picture Style.

Portrait.

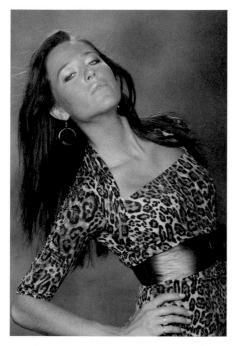

Landscape.

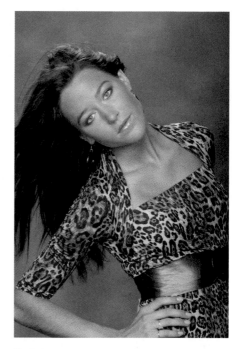

Neutral.

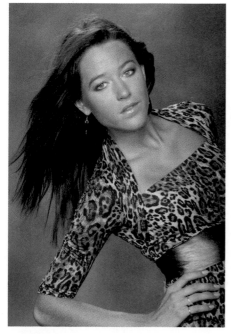

Faithful.

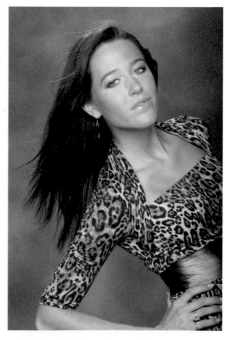

Monochrome.

Should you find a favorite but wish to make changes to suit your style, you have two options. First, you can enter the style itself by selecting the style you wish from the menu. Select Picture Style and press the Set button to reveal all styles. Use the Cross Keys to select the style you want. Press the Display button to open the parameters. Press the Set button again to open the selected parameter. Use the Cross Keys to make the change and press the Set button to make it happen. You can always go back to the original parameters because the original settings show as grayed-out markers. Just shift your marker back to the original position and press Set.

Your second option is to create your own picture style, using one of the presets as a base. You can create up to three user-defined picture styles by first selecting Picture Style and scrolling to User Def. 1, 2 or 3 with the Cross Keys. Press Display to get inside. Select the base Style and press Set again. Set as many of the additional parameters as you need, using the Set button and Cross Keys. Your final user defined style will be ready to use whenever you need it.

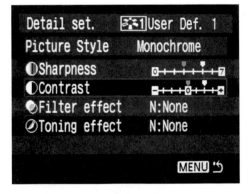

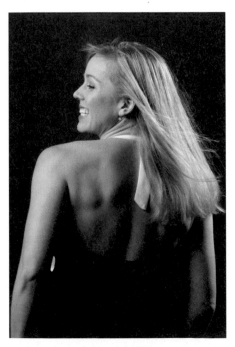

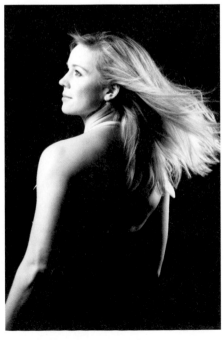

Using monochrome without changes.

Monochrome as seen by User Def. 1.

Dust Delete Data The Rebel was the first Canon camera to incorporate Automatic Sensor Cleaning, an ultrasonic system that vibrates dust and grit from the sensor on to a special adhesive strip, and the technology is being adapted to the entire Canon line. Frankly, it's so effective you may never need to use this feature. It's also extremely difficult to illustrate a Dust Delete scenario with the small images in this book. Suffice it to say that the instructions that accompany the camera are easy and precise. If you have a persistent dust spot, it's a simple matter for the camera to make note of it and eliminate it on any image made after the feature is inaugurated.

PLAYBACK MENU

Protect You can protect images from accidental or intentional erasure by selecting this feature, scrolling through your images, and using the Set button to mark each selected image. You'll see a small icon, a key, appear on the selected images. Images marked with this icon will not be erased, even if you choose "Erase all images" from the Erase menu (although you will not see the icon on subsequent viewings of the image unless you view it via the Shooting Information display).

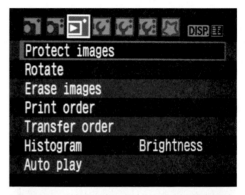

Please note that Protect will not save any image if the card is reformatted. Always be sure your important images are backed up before making *any* irrevocable change to the original storage media.

Rotate This feature rotates a vertically framed image to a horizontal format for viewing on screen or computer. See Set Up Menu 1, Auto Rotate, for a once-and-for-all solution to this problem.

Erase Images This feature allows you to erase selected images or an entire card. You can also erase images by initiating

the Playback feature and pushing the Trash icon on the back of the camera. Push the Set button to OK the erasure. Note that once an image is erased, the camera cannot recover it.

Print Order You can specify the information, if any, that you want to appear on your prints. Working with any PictBridge Printer, you tell the machine to print single, multiple, or index print images. Note that this feature does not work with RAW images.

Transfer Order This feature allows you to select up to 998 images to be transferred to your computer in or out of order. Note that the phrase "Clear all on card" only means that images selected for transfer will be deselected, not erased.

Histogram Select either the traditional black-and-white histogram (Brightness) or the RGB histogram, which details brightness levels in each channel.

Auto Play You can view each image on the card as an impromptu slide show on the camera's LCD. Use the Set button to pause or resume the show. Press the Menu button to exit Auto play.

SET UP MENU 1

Auto Power Off Use this feature to determine how long the camera will stay active before going to sleep. Setting the control to Off tells the camera to be ready indefinitely and will deplete the battery more rapidly (and you'll have to manually turn the camera off), but choosing a short time span of 30 seconds or 1 or 2 minutes will, I'm sure, prove to be frustrating for you. If you choose Off, the display will automatically turn itself off after 30 minutes.

File Numbering Your Rebel has three choices for file numbering: Continuous, Auto Reset, and Manual Reset. Continuous will place a number from 0001 to 9999 on consecutive images. When 9999 is reached, the camera will ask if you wish to start a new folder. Selecting "Yes" is a good idea if you have any hope of continuing in the same manner.

Auto Reset will start with 0001 whenever you replace a CF card. Manual Reset will create a new folder with images starting at 0001 whenever it is selected. This can be useful if you wish to separate certain portions of a shoot such as prewedding, ceremony, and reception.

Auto Rotate You can tell the camera to automatically rotate, on playback, any vertically shot images. Choose the uppermost selection, with the camera and computer icons, and the images will be rotated on your computer screen as well.

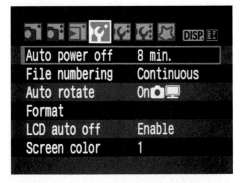

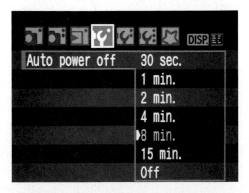

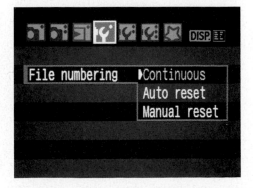

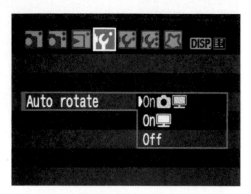

Format This feature completely erases all images (even protected images) and reinitializes a CF card. If you've adequately backed up all data from a card, format it when you replace it in the camera, as that process is cleaner and more efficient than simply erasing.

LCD Auto Off You've probably noticed that the information display on the LCD disappears as you bring the camera to your eye. This is due to a tiny sensor just below the viewfinder. Should you want access to the LCD information all the time, even when it's shining in your eye, this feature will disable the sensor.

Screen Color Your Rebel allows you to choose four different color schemes for the LCD.

SET UP MENU 2

LCD Brightness Maintaining a middle setting will give images viewed on the LCD the best color and contrast range the device is capable of rendering. Still, it's sometimes useful, especially outside, to boost the brightness. Note that LCD screens are never completely accurate and should never be used to judge critical exposure or color.

Date/Time Set the date and time. This may seem about as important as setting the time on a video recorder, but you should do it because the date and time are recorded in the metadata of each image you make. Use the Cross Keys to dial in the correct date and time, and press Set when you're done.

Language You have your choice of 20 selections for the interface language. Hopefully, this book will be translated into all of them.

Video System Depending where you are in the world, and if you wish to show your pictures on a television, you'll need to select the correct video system.

Sensor Cleaning: Auto Canon recommends you leave this feature set to its default, which is automatic cleaning when the camera is both turned on and turned off.

Sensor Cleaning: Manual There may come a time when a persistent little chunk of crud will not respond to automatic cleaning. Canon recommends that you send the camera in for professional cleaning, but that's

not always practical. If you must clean the machine yourself, follow these instructions. Please note that the sensor is *extremely* delicate. Do not touch it with anything and do not blow canned air across its surface. Should the canned air's propellant spray onto the surface of the sensor (it dries immediately), well, you probably will be sending the camera in for service.

1. Select Sensor Cleaning from the menu.
2. Select Clean Manually from the submenu.

3. Click OK and you'll hear the mirror lock up a second or two later.
4. When you're finished cleaning, the mirror will return to its normal position once the camera has been turned off.

5. Hold the camera upside down to keep dirt from falling onto the exposed sensor, remove the lens, cap it, and set it aside. From below, aim an air bladder at the sensor and the sides of the barrel. Don't be shy. Squeeze the bladder hard and rapidly to blow crud off the sensor. When you're

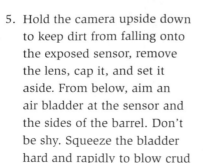

finished with the sensor and while the camera is still upside down, turn the power off and repeat the air treatment to the mirror.

At this point, it's a good idea to put the body cap on the camera, set it aside, and blow dust off the lens mount. Hold the lens mount-down, so gravity works with you. If you have other lenses, clean them at this time, too.

Live View Function Settings One of the most significant advances in the Canon line is the ability of DSLR cameras to "see" through the lens to the LCD, much the same as point and shoot cameras. This can be helpful in situations where it's difficult to look into the viewfinder.

To use Live View, follow these steps:

1. Select any mode in the Creative Zone. Live View does not work in Basic Zone.

2. Press Set to enter the feature and select Live View Shoot>Enable.

3. Press the menu button to exit and press Set again. Your scene will appear on the LCD screen.

Note that shutter speed and aperture can be adjusted, as you watch the screen, by using the Main Dial and the AV button. Before the image is taken, the mirror will drop back into place and auto focus will be performed. Because of the delay, it might be a good idea to use a tripod or other support to eliminate movement.

The Live View function will continue until you disable the feature or turn off the camera. You can also use the function to view live images on your computer or television.

Flash Control This function controls either the built-in flash or an external flash connected via the hot shoe. For example, you can disable the built-in flash so that it won't pop up under any circumstances. If you manually raise the flash, the red-eye reduction flashes will go off but it will not flash when the shutter is opened.

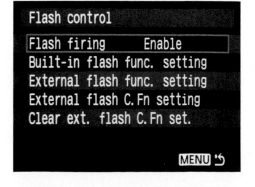

When working with the built-in flash, the most important subfunction for you will probably be **Built-in flash func. setting**. This subfunction allows you to choose 2nd Curtain Sync, which fires the flash at the end of the shutter actuation rather than at the beginning. If you're working with moving subjects and longer exposures, this means that subjects that streak will be frozen in place at the end of their motion rather than the beginning.

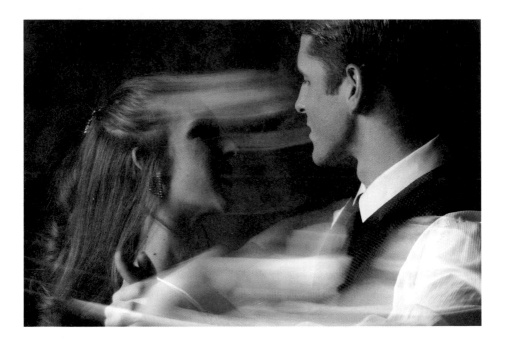

You can also dial in Flash Exposure Compensation to increase or decrease the strength of the flash regardless of the aperture, which is useful in fill flash situations.

SETUP MENU 3
CUSTOM FUNCTIONS (C.FN)

Bend the camera to your will, but only in the Creative Zone. These features are not available to any Basic Zone setting.

By using Custom Functions you can customize many important features of the Rebel until you get a camera that truly fits your requirements and shooting style. Access the Custom Function

(C.Fn) screen through the Set Up 3 submenu in the menu. Press the Set button to enter each function. These functions have changed significantly with the XSi/450.

Use the left and right Cross Keys (or the Main Dial) to select the C.Fn by number or title. Pressing the Set button again will enter the selected function and highlight the current selection. Use the top and bottom Cross Keys (or the Main Dial) to move through the actual selections. Selections will be highlighted; press the Set key again to register your choice.

Pressing the Menu button will exit Custom Functions with your selections registered and ready to use.

C.Fn 1: Exposure level Increments The Rebel defaults to $^1/_3$ f-stop increments, but you can select $^1/_2$ stops. Increments of $^1/_3$ leave less room for exposure error.

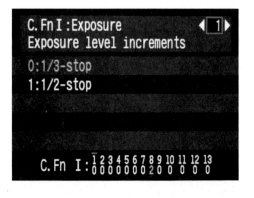

C.Fn 2: Flash Sync. Speed in Av Mode The camera adjusts the intensity of the flash based on the scene and will attempt to balance the ambient light of the scene to the power of the flash in any exposure from 1/200 of a second to 30 seconds. In some cases, this results in camera shake, because the ambient light is dim and the exposure is long.

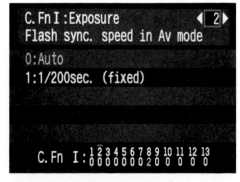

> C.Fn-2:0 *Auto*. The flash is adjusted to the scene.
>
> C.Fn-2:1 *1/200 sec. (fixed)*. The flash will pump out as much power as it needs (up to its useful limit, of course) to achieve a perfect exposure at 1/200 of a second. Camera shake is no longer an issue, but ambient light may not register.

C.Fn 3: Long Exposure Noise Reduction Although the Rebel's advanced sensor and processing technology do a great job of noise reduction, long exposures can still present some problems. Using this function for exposures that are longer than 1 second reduces (but does not eliminate all) noise, resulting in a smoother image. The downside to this function is that it takes the camera more time to reduce noise than it does to process the image, and additional

C. Fn II : Image 3
Long exp. noise reduction
0:Off
1:Auto
2:On

C. Fn II : $\begin{matrix}1&2&3&4&5&6&7&8&9&10&11&12&13\\0&0&0&0&0&0&0&2&0&0&0&0&0\end{matrix}$

pictures can not be made until the previous one is processed.

C.Fn 4: High ISO Speed Noise Reduction The camera will look at the image as it's created and attempt to determine if undetected noise (noise the camera does not automatically compensate for) is present. If it is, the Rebel will automatically apply noise reduction.

With high-speed noise reduction.

Without noise reduction.

C.Fn 5: Highlight Tone Priority This is trickle-down technology from the Mark III and addresses the problem of blown out highlights in high-contrast situations. This function extends the dynamic range, the number of tones that can be correctly produced.

When you use it, the lowest available ISO will be 200. The ISO designation on the display will change to read 2oo (or 4oo, 8oo, etc.) indicating that Highlight Tone Priority is in use. Wedding photographers, who do not always have the luxury of testing exposure before shooting the "money" shot, have had problems balancing the bleached and blued whites of a wedding dress against the light-absorbing

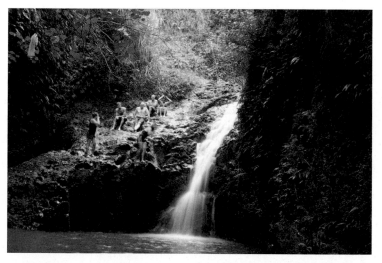

With Highlight Tone Priority.

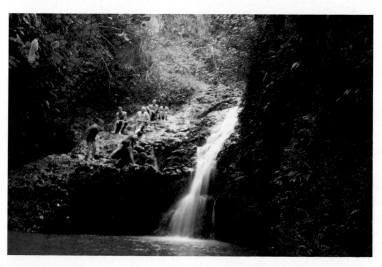

Without Highlight Tone Priority.

blacks of tuxedoed groomsmen. Highlight Tone Priority effectively addresses this problem, as well as the problem of white-on-white tones. Obviously, this function can be useful for any subject matter that would be improved by an expanded dynamic range.

C.Fn 6: Auto Lighting Optimizer This new function looks at your exposures and determines if they are too dark or lacking in contrast; if they are, it corrects them. Depending on the actual shooting conditions, some additional noise may be generated. Please note that this function will not operate with manual exposures, RAW, or RAW+L files, but it does automatically work in any Basic Zone mode.

C.Fn 7: AF-Assist Beam Firing The camera emits a beam to assist the auto focus mechanism. You can enable it, disable it, or allow it to work only through a Canon Speedlite.

C.Fn 8: AF during Live View Shooting Choosing either the Quick Mode or Live Mode option will allow you to auto focus through the LCD screen when Live View Shooting is enabled. Use the FEL button to achieve focus and press the shutter when the moment is right.

C.Fn 9: Mirror Lockup Long exposures or extreme closeup photography will often display a slightly unsharp image or a faint "ghost" image caused by the slight vibration of the mirror when the shutter opens. When

Mirror Lockup is enabled, you will have to press the shutter button twice to take the picture. The first click will lock up the mirror, the second will make the image. It's a good idea to use an RS-60E3 Remote Switch to fire the shutter so your fingers will not contact the camera.

C.Fn 10: Shutter/AE Lock Button Using this function allows you to change how focus and exposure are acquired. (More info on pp. 57–58)

C. FnⅣ:Operation/Others ◀10▶
Shutter/AE lock button
0:AF/AE lock
1:AE lock/AF
2:AF/AF lock, no AE lock
3:AE/AF, no AE lock

C. Fn Ⅳ: 1 2 3 4 5 6 7 8 9 10 11 12 13
0 0 0 1 0 0 0 0 0 0 0 0 0

> C.Fn-10:0 *AF/AE lock*. Both Auto Focus and Auto Exposure are made at the shutter button. This is the camera's default setting.
>
> C.Fn-10:1 *AE Lock/AF*. This func-

tion allows you to focus and meter separately, using the AE Lock/FE Lock button on the back of the camera to focus. Known as Thumb Focus or Back-Button Focus, the benefit is increased speed in shooting because the shutter button does not have to acquire focus before firing. When a photographer uses this function, along with a selected focus point, focus may be selected, held, or changed while exposures are made with the index finger. It takes a little practice, but once you're used to it you'll wonder how you got along without it. Use this function with AI Servo and you can focus on a moving object, hold the back-button down, and fire the shutter as you wish. Your subject will stay in focus as long as you don't release the button.

C.Fn-10:2 *AF/AF lock, no AE lock.* If you're using AI Servo AF to track a moving subject in a cluttered environment, you can use the AE Lock/ FE Lock button to stop AF if there is a possibility something will move between you and the subject and throw off the AF. Exposure will be measured as images are made.

C.Fn-10:3 *AE/AF, no AE lock*. This is similar to C.Fn-4:2 except that AI Servo AF can be turned on and off with the AE Lock/FE Lock button. Use this function for subjects with repetitive movements. Exposure will be measured as images are made.

C.Fn 11. SET Button When Shooting You may assign some favorite or oft-used tasks to the Set button. Once set, you may call up the chosen feature any-time during the shooting process by pressing the Set key (unless the main menu is active on the LCD), and you can move through its options via the top/bottom Cross Keys, effectively bypassing having to search the menu.

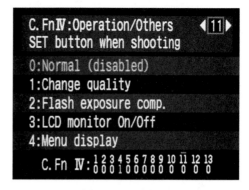

C.Fn 11:1. Change Quality. Quickly changes the compression settings for your images.

C.Fn 11:2. Flash Exposure Compensation. You can make the built-in flash deliver (in $\frac{1}{3}$-stop increments) more or less power than the camera thinks it needs for a perfect exposure. This is useful in situations with a bright object against a dark background or vice versa and allows for faster correction than through the menu. In my opinion, this is the most useful option of C.Fn-1.

Please note that this function is deactivated if an accessory flash is mounted to the camera's hot shoe. Use the compensation function of the accessory flash to make any necessary corrections.

C.Fn 11:3. LCD monitor On/Off.

C.Fn 11:4. Menu display. Returns to the last menu item selected.

C.Fn 12. LCD Display When Power ON For those moments when you do not want the dis-play to illuminate when the camera is powered, select C.Fn 12:1, Retain power OFF sta-tus. Push the Display button to turn off the LCD, and turn the camera off as well. When you turn the camera back on, the LCD will not light although you'll still be able to review your

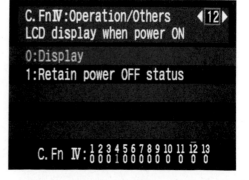

images. Push the Display button again to see the info or to bail out of this selection.

C.Fn 13. Add Original Decision Data Most of you will never need this function. It works in tandem with Canon's Original Data Security Kit and can prove (to law enforcement, perhaps) that an image is original and unretouched. You'll need to purchase the OSK-E3 kit separately in order to verify the claim.

CLEAR SETTINGS

You can reset every customizable feature of the camera, or just the Custom Functions, to their default settings.

FIRMWARE VERSION

Canon periodically posts firmware updates on its website. You can use this feature to update by downloading updates to the SD card.

MY MENU

You can register up to six menus and Custom Functions for features you use frequently. For example, I frequently use Custom White Balance, switch from Adobe RGB to the sRGB Color Space, and use C.Fn.II:5, Highlight Tone Priority. I can access any of these functions without scrolling through the individual menus, so this is a real time-saver for me.

To register your favorites, select Register and scroll through the menu items until you find your favorites. Use the Set button to register them. When you select My Menu, you'll see the list of your registered favorites. You can access any of them by just selecting them and pushing the Set button.

Cards, Readers, and Batteries

MEMORY CARDS

The Digic III processor in the Rebel XSi/450 supports both Secure Digital (SD) and Secure Digital High Capacity (SDHC) memory card formats. Memory cards are priced based on their data transfer speed (DTS). Cards with a Class 2 rating are guaranteed to sustain a DTS of 2 megabytes/second, whereas Class 4 and Class 6 cards sustain rates of 4 and 6 megabytes/second, respectively.

The DTS numbers for the Digic III are not available from Canon. Suffice it to say that it's very fast. I made a simple and totally unscientific test to determine how inexpensive SD cards compare to their faster, more expensive brethren just to see what would happen. The inexpensive card was a free 2 GB giveaway from a local office supply store, whereas the other was a 2-GB SanDisk Extreme III card that reads/writes at a minimum DTS of 20 MB/second.

I set my Rebel to Continuous Shooting and began firing. The free card was slow enough that the buffer filled after 40 frames and then required approximately 20 more seconds to write the remaining images to the card. The SanDisk card was not able to overpower the buffer, registering more than 100 continuous frames before I stopped shooting. The camera needed less than a second to write remaining buffer data.

What does this mean to you? First, any card will work perfectly well for basic, snapshot applications. There's no need to spend a lot of money (and you can certainly get great results

with a freebie). However, if you plan on shooting sports or any subjects that require continuous shooting, spending more for a better card is a good idea.

CARD CARE

Unlike earlier Rebels, your XSi/450 uses the newer Secure Data (SD) cards. It may be hard to believe that something so small can hold as much data as it does, but it's actually a precision instrument manufactured to exacting tolerances that can give you years of flawless performance when treated with tenderness, love, and respect.

Notice that there's a lock slider in the upper left corner. Use this whenever you have stored information that you do not wish to overwrite, even accidentally. When the lock is engaged, the data may not be added to or downloaded.

To get the highest level of performance, here are some recommendations for card care:

- Avoid dropping the card. Even tossing it casually onto your desk can damage it.
- Avoid strong vibrations.
- Don't use or store the card in strong magnetic fields. You could lose data.
- Leaving the card in strong sunlight or heat could warp it.

- If you spill liquid on it or drop it into water, clean it carefully with a damp cloth and let it dry completely before trying to retrieve your data. You may get lucky (and probably will—personal experience).
- Store the cards in their cases to keep dirt off the contact points.
- Don't flex or bend the card or keep it in your pocket. It's not a lucky charm.
- Hot, dusty, or humid conditions are bad but hard to avoid. Keep the card as protected as possible.

CARD READERS

Although you can tether your camera to your computer and download using Canon's software (explained elsewhere), many people prefer to use a card reader. Most efficient card readers are either USB-2 or Firewire devices and are inexpensive.

If you also work with a camera that uses the CF card format, memory stick, or some other format, there are readers on the market that are equipped to read all cards. They are also inexpensive.

Bear in mind when downloading that a high-speed card reader will not make a slow card any faster. Cards can only read and write at their stated transfer speeds.

BATTERIES

The XSi/450 takes advantage of ongoing power supply research and uses the new LP-E5 Li-ion battery pack. About the same weight as

previous batteries, this new item will give you approximately 20% more exposures per charge than its predecessor while still maintaining a rapid recharge time.

This Rebel no longer requires a separate date/time battery. Instead, a small and inaccessible rechargeable battery inside the body draws a tiny amount of power from the LP-E5 to sustain itself. Bear in mind that if the LP-E5 is stored outside the camera for too long, you may have to reset the Date/Time Function when you replace the battery.

The battery charger that's supplied with the camera is compatible with any country's AC power between 100 to 240 volts and 50 to 60 Hz. You may have to purchase a commercially available adapter for other countries.

If you are worried about depleting the battery but have access to AC power, you can purchase the AC Adapter Kit (ACK-E5) and run the camera indefinitely off household current. Canon warns you not to connect or disconnect the power when the camera is turned on.

BATTERY CARE

- Even if you recharged the battery after using it the last time, plug it in and top it off before using the camera. A small amount of electricity will be continuously discharged whenever the battery is in the camera.

- Canon recommends you remove the battery when not using the camera. This could be problematic if you consistently leave it out too long and

have to reset the Date/Time Function every time you get ready to shoot. Unfortunately, there are no data as to what "too long" actually is.

- Keep the battery covered when not in use. Dirt in the contacts can affect battery performance.

- Like everything else, batteries have a finite life. When yours no longer holds a charge or doesn't perform like it used to, it's time to replace it.

CAMERA MAINTENANCE

Your Rebel is a precision instrument, and dirt is its nemesis. Use an air bladder to gently blow off dust from all surfaces, but pay particular attention to areas around the lens mount, as this is where dust will enter the mirror and sensor assembly. Stubborn grit on the camera surface can be removed with a soft brush followed by the air bladder (never use a brush on the sensor). Clean the camera with a lens attached to maintain a seal against outside elements.

Use a clean microfiber cloth to wipe the lens and viewfinder. For the LCD, spray a small amount of glass cleaner onto a clean soft cloth or microfiber cloth. Never spray directly onto the LCD or any other part of the camera. Wipe off any fingerprints.

See Menus>Setup Menu 2>Sensor Cleaning for detailed instructions on how to properly clean the image sensor.

The Software

Canon includes, with all EOS cameras, a copy of the EOS Digital Solution disk. On it you'll find programs for both Macintosh and PC computers designed to make your digital lives significantly easier. These are rather deep programs, however, and have been engineered with subtleties that are simply impossible to completely investigate in this guide because of page restrictions. I would suggest you use the following as a knowledge base, quick-start information to customize your workflow as your understanding increases.

EOS UTILITY

Canon's EOS Utility (EU) is what you'll use to talk between your camera and computer, to download images from the card, and to tether the camera to the computer to see each image much larger than you ever could on the camera's LCD. There are also some camera settings that you can control with your computer. Be sure to check your computer against the list of system requirements noted in the manual before downloading the software to your computer.

DOWNLOADING IMAGES

Your Rebel was supplied with a transfer cable for the camera/computer hookup. With the camera turned off, connect the small end into the camera's Transfer socket.

Plug the other end into the computer's USB port and turn the camera on. The EU Main window appears.

The first selection, "Starts to download images," will download all images on the card. EU will also sort the batch by date into folders, and it will launch Digital Photo Professional (DPP) so you can edit immediately, if you wish (see Digital Photo Professional for instructions). The default location for downloaded images is Users> Pictures, but you can change that if you wish by selecting File>Open Destination.

Of course, you can build a file of individually downloaded images. From the Main window, click on "Lets you select and download images." Select the image you want and click the Download button on the bottom of the screen. You may determine a destination location other than Users>Pictures before downloading if that's more convenient for you.

Note that EU does not recognize third-party card readers, only cards in the camera. If you prefer not to use EU, you can download directly into DPP or ImageBrowser. You could also open the card in a third-party reader and drag and drop the images (without any previews) into a selected or new folder. Use EOS Digital>DCIM>100Canon to find the file list. Select All and drag your images wherever they need to be.

Quit EU when you're done.

USING YOUR COMPUTER TO SET THE CAMERA

Start the camera as before, then select Camera settings/Remote shooting to access functions.

A new window, called the Capture Window, appears. You'll notice the same menu symbols that you see in the main menu, one each for Setup, Tools and My Menu. You'll also see that the camera's current Zone, Creative Controls, Meter mode and other controls are represented by their respective icons. All of these functions may be accessed and changed through your computer, just by clicking on them. Any change you make in the camera will be mirrored on the computer screen.

Additionally, the bottom row of buttons allows you to jump to the Download Images' DPP window, see a Quick Preview of an image, or activate Live View shooting for tethered shots (and make additional adjustments to the camera, even fine-tune the focus).

The last of the four buttons will shoot a test image, which will not be written to the card or the computer.

The Tools menu, in addition to setting Date and Time and the Live View settings, lets you add your name as the camera owner. Also, if you're hooked up to the Internet you can upgrade the camera's firmware just by clicking.

As you might expect, some items are accessible through this item that you won't be able to find any other way. For example, Canon has included an intervalometer, a device that will automatically fire the camera at pre-determined intervals. Want to watch paint dry? Grass grow? Set the timer accordingly and walk away. The camera will shoot as many frames as you wish, at intervals that you specify. You can even set it to shoot a series of time exposures. This is a very cool toy.

To exit at any time, just click the Main Window button.

REMOTE SHOOTING

Tether the camera to the computer as before, and turn the camera on.

Check Preferences and tell the camera if you want to make any changes to any of the options. For example, you can determine which folder you want the pictures to be placed in or create a new folder, whether you want the image written to both the card and the computer, whether you want to change the file name, and so on.

From the Tools menu, select Live View function settings>Enable> Return.

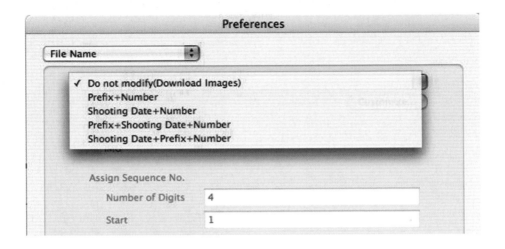

When you've made necessary changes to the camera's operation and are satisfied with any test shots, push the shutter button in the top right corner of the Capture window. Your shot will appear on your computer screen. Note that if you need to shoot with the camera it's not necessary to disconnect it from the computer. This is valuable if you've run out of card space because you can write directly to your computer's hard drive.

The final selection, "Monitor Folder," is not used by the Rebel.

DIGITAL PHOTO PROFESSIONAL

A RAW file is considered the digital equivalent to a film negative (thankfully without the requisite liquid chemistry) and can be affected by a variety of software controls to create a .tif or .jpg file delivering exactly what you want to present. It does take additional time to work a RAW file, which is something you need to consider if you're working with a large number of images, but the extra effort can be worth it if you need a superlative final product for an advertisement, commercial, or fine art piece.

Canon's RAW conversion software was built for Canon files only. Because Canon does not share its architecture with other manufacturers, those companies can only create programs that *generically* do the

job. Consequently, those other manufacturers, whose goal is to create generic translators that work with any RAW code, cannot incorporate the subtleties and nuances available to the engineers at Canon. Of course, color and exposure can also be adjusted in other programs, but why would you want to take that extra time?

Another, significant, benefit from working with Canon's DPP software is the reduction of noise in a processed image. Noise is a natural by-product of signal amplification, how the camera defines ISO, a term that originally defined how sensitive film was to light. Camera manufacturers have programmed their sensors to mimic that same scale, so that at ISO 100 an exposure of 1/100th of a second under bright sun at f16 on film (the Sweet Sixteen rule) will yield the same results with digital media. To get higher ISO, film photographers had to switch film stock or "push process" the film at the lab. Digital cameras create higher ISO by amplifying the signal that reaches the sensor chip, but the higher the camera's

TIP

A RAW file itself is never changed, no matter how you change the screen image. When you see a RAW image on your screen, you're looking at an image influenced only by the conditions under which it was shot and the manipulations that you make in the conversion software. When you like it, tell the machine to Convert and Save and a new file will be created as a TIFF or JPEG (your choice). The original RAW file information can be revisited any time, and it remains intact until removed or deleted.

ISO, the more noise it produces. Because Canon's DPP software was built for its own chips, it has built-in noise reduction, engineered only for Canon, that generic RAW converters simply cannot target. Noise is typically most prominent in darker tones or shadows and with higher ISO speeds.

DPP uses two windows for its operation. The Main window acts like a browser; you point it to the folder you wish to view, select it, and all of that folder's contents show up in rows of thumbnails.

Select one, some, or all of the images, then select Edit Image window from the button menu at the top. Doing so will call up a second window, the Edit window, and your selected images will appear in a vertical row on the left. The first image from the selected group will appear large in the main portion of the Edit window. You'll note this image will look fuzzy for a few seconds, as DPP renders the file.

Now that you're initially familiar with the two windows, let's back up for a moment. DPP magic can happen in either window, and I want to focus on the Main window before we proceed.

With the Main window open, click the Folder View button to hide the Drive menu on the left and maximize the rows of thumbnails. Dragging on the expansion tab at the lower right corner will expand the screen even further, as long as you have room on your monitor.

Select All highlights every image in the folder; Clear All de-selects them.

You can select each image individually and rank them in order of importance (first, second, third) by clicking the Check1, Check2, or Check3 buttons.

Obviously, the Clear Check button will clear any previously checked files.

Rotate Left and Rotate Right will turn the selection in 90° increments.

Any of these controls can be applied to both RAW and JPEG images. Previous editions of DPP had additional, redundant controls built in to the Main window. Canon has streamlined DPP with v3.3.1.3, which was shipped with the camera.

If you're happy with what you've done to your images in the Main window, select Batch Process to convert them into real TIFFs or

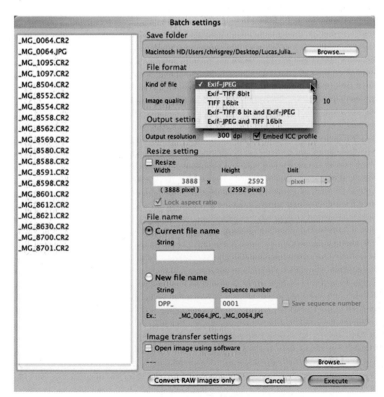

JPEGs. You'll see a new window appear, the Batch Settings window, where you'll make decisions as to where the processed images will go, what kind of file (16 bit TIFF, 8 bit TIFF, or JPEG) they'll become. Additionally, DPP can resize images up or down from their original file sizes. This is especially valuable if your client needs a high-quality file for a larger-than-normal use, a two-page magazine spread for example.

THE EDIT WINDOW

By default, the Edit window opens with Thumbnails and Tools selected, so that you'll see the first several of your selected images along the left and the Image Adjustment toolbox at the right. Should you choose to edit individual images, the tools in this window alone will probably accomplish 90% of your goals with DPP.

Select the images you wish to work on and click Edit Image window. Now that you've seen the Main window, the first thing you'll notice is that there are new buttons to work with, as well as additional Rotate and Batch Process buttons. You'll also notice three buttons at the top of the Toolbox window: RAW, RGB, and NR/Lens. If you shoot in RAW you'll be able to work in all three windows, and each does different things.

The Main Window button will return to the file selection, of course. Selecting Thumbnails will isolate the image currently selected so that

you may study it without the distraction of other images or colors. It is presented on a neutral background and permits you to use any of the controls on the right.

Selecting Tool hides the toolbox on the right so that you may study the effect of what you've done against a neutral field.

Use Grid to place gridlines over the image. Grid pitch may be changed in Preferences.

Magnify the image by 50% to 200% by clicking on the appropriate button. Click Fit to Window to return.

RAW IMAGE ADJUSTMENT

Note that you can revert to the original shot settings at any time by selecting the Return button, located on the right of each adjustment bar.

For image correction, use the Brightness slider to affect exposure up to two stops either brighter or darker.

TIP

DPP offers adjustments over a four f-stop range, which means you should be able to salvage an image that was overexposed by up to two full f-stops, a feat that's not possible with any software if your original shots were JPEGs only, because digital exposure is the most fussy on the high end. With JPEGs, an overexposure of only $+\frac{1}{3}$ stop will damage the image, and the loss of data will not allow detail to be brought back. It can't be "burned in" like overexposed detail in traditional negatives because it simply doesn't exist. Shooting RAW is a partial solution to over- and underexposure issues but will take more of your postproduction time. Use it wisely.

This image was deliberately shot using the Tungsten color setting. Because tungsten light is very warm, the camera added a lot of blue and cyan to counteract the low color temperature. Fortunately, the image, which was shot in daylight, may be easily rescued in DPP.

White Balance adjustment can be made a number of different ways. Clicking on Shot Settings calls up an extended color temperature preset scale. Select any of the presets and the color will instantly change to reflect that color temperature.

Select Color Temperature from the extended scale, and a slider will materialize. Move the slider left or right to get a color temperature you like.

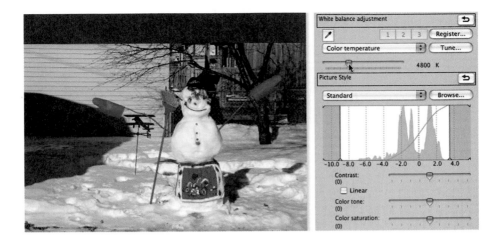

Selecting Tune will call up a color wheel. Put the cursor on the center dot and drag it around until you're happy. You can get any color shift you could possibly ever want by using this tool.

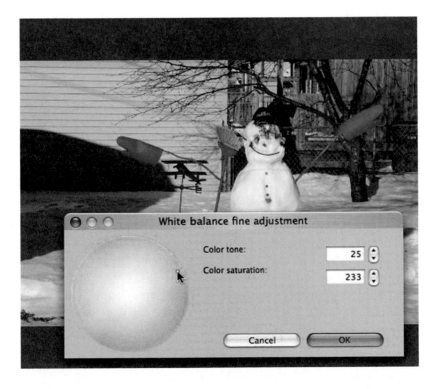

It's also possible (and very easy) to register up to three Custom White Balance settings. Simply select the White Balance setting you'd like to use by choosing from the dropdown list, using the slider under Custom White Balance or the Color Wheel.

In the Register window, select Custom 1, 2, or 3, then click OK. Your color temperature selection is available anytime until it's changed.

Although custom color temperatures can't be set at the White Balance window in the Main window, those set in the Edit window will be available in the Main window after they have been registered.

I'm sure you can see the importance of a control like this. Many wedding photographers shoot everything in RAW format, preferring to take the time to fine-tune each image before processing and printing. Many of those images are made with on-camera flash and sometimes look a little flat. Adding a little extra warmth by changing the color temperature from 5600 K to 7500 K might be beneficial to the final product and can be accomplished easily. Beauty and glamour photographers frequently want an even greater level of warmth in their images, perhaps all the way up to 10000 K. Like all controls in any Canon camera, I merely ask you to play with them and make your own decisions as to how your vision is to be represented.

If you like the concept of changing an image's color temperature and want to apply it to existing, non-RAW, images, I've outlined a simple yet versatile Photoshop formula in my book *Photoshop Effects for Portrait Photographers*, also from Focal Press.

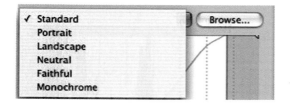

PICTURE STYLES

You can, of course, set any Picture Style you wish in the camera. If you shoot JPEGs, and you want a look that's different from what is considered "normal", that's what you'll have to do, of course. The beauty of RAW and the Edit window is that you have access to all of the Picture Styles, so you can toggle between them to see what looks best, without locking yourself in to a camera-processed style.

Picture Styles are like processing films from different manufacturers in the same chemistry; they all slightly vary in color and look. Whether you use Photoshop for final tweaks or not, the ability to rapidly but consistently alter the Picture Style gives you unprecedented creative freedom over the look of your image. See Picture Styles for more information and comparison images.

ADJUSTING DYNAMIC RANGE

What appears to be a traditional histogram is actually a Dynamic Range adjuster. The image in the Edit window originally showed a

dynamic range of −9.0 to +3.6. You can change these numbers by moving the shadow slider (on the left) and the highlight slider (on the right) toward the middle. Moving either slider eliminates some of the shades of light or dark that comprise the image, making transitions from white (no detail) to highlight detail, or black to shadow detail, shorter than what was shot. Although you might wonder why you would ever want to shorten the dynamic range, this tool is quite practical; if you're shooting for a critical application and you know the maximum dynamic range of that application is, say, −8.4 to +2.0, you can make those changes as well as necessary Brightness adjustments to get the best possible representation of your image in a shorter dynamic range. If you do not do this, it's possible that the image will be tonally clipped when it's reproduced.

Just below the Dynamic Range window is a nameless graduated slider that you can use to raise or lower the contrast of the image as it appears after you move the sliders or by itself, without any DR adjustment. It's extremely useful for fine-tuning an image with a shortened dynamic range.

Checking the Linear box below the contrast slider will flatten the curve and seems to show an average of represented pixels within the image, actually adjusting the Linear Tone Curve. This is a tool generally used by advanced users to create their own custom profiles. You've been warned.

Below the Dynamic Range graph are three more sliders that are important to any of the Picture Styles: Color Tone, Color Saturation, and Sharpness.

Color Tone skews the overall color of your image in either of two directions. Slide to the left, and the tone takes on more red. Move it to the right, and the image gains yellow. This is a useful tool if you need to add to or mellow out colors in a general way.

Color Saturation, like its Photoshop counterpart, either saturates or desaturates the color strength of your image.

Sharpness decreases or increases the Sharpness level, as you wish.

Black and white is back! Canon's Monochrome Picture Style is absolutely outstanding, producing neutral tones of great depth and full of visual

For truly neutral results on self-printed prints, there are a few things you should know. Many inkjet printers will not print a neutral black-and-white print, even if you send it a neutral file. The standard inks are not designed to do that, and results typically show a slight magenta or green cast. If your printer allows true black and white, you may first have to flush the ink delivery system and change cartridges, a somewhat expensive routine because of wasted ink. Some new printers, like Canon's image-PROGRAF line, can produce beautiful neutral images without skipping a beat (or changing a cartridge). Check and test your equipment before starting a money job.

There is a new online service, MyBWLab.net, that uses new color management technology to produce beautiful almost perfectly color-neutral black-and-white images from wallet size to 30 × 40, something that few labs can guarantee. Prints smaller than 11 × 14 have traditionally been made on machines that cannot be color-managed tightly enough for truly neutral images, but these folks have ironed out the wrinkles.

information, with natural highlights and terrific shadow detail. DPP uses an almost identical algorithm to the Picture Styles algorithm in the newer cameras, with a few additional features.

When you select the Monochrome Picture Style, you'll notice changes to the secondary control sliders. The Color Tone and Color Saturation sliders, respectively, change to Filter Effect and Toning Effect.

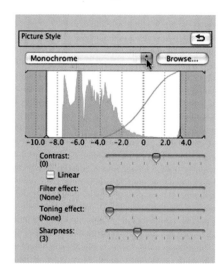

FILTER EFFECT

Those of us who shot lots of black-and-white film will no doubt remember the colored glass filters we used to alter the wavelength of the light that struck the film. In portraiture, women were often photographed with yellow or orange filters because they would lighten skin tones. Men were sometimes photographed with a green filter, which would darken the skin slightly, presumably to give them more character (a look referred to in more than one book as "swarthy"). Nature and architectural photographers would routinely use a red filter to darken blue skies or a green filter to lighten foliage because the filters would lighten colors similar to themselves while darkening their opposites.

Canon's software engineers designed the four most popular black-and-white filters—yellow, orange, red, and green—into this nifty little slider, and, like all the effects in DPP, the application of each can be viewed in real time. Take a look at each and make your own decisions.

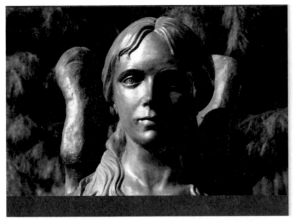

No Filter effect.

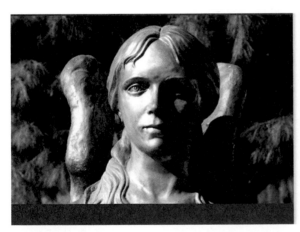

Red Filter applied.

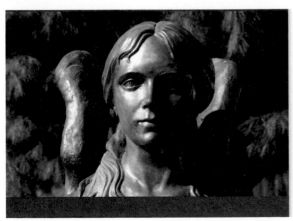

Green Filter applied.

TONING EFFECT

Just below the Filter slider is Toning Effect. Should you be looking for the classic sepia-tone look of older, silver-based, photographs or just would like to put some extra zip into a black-and-white image, you might find what you need here. Chemical toners were designed to replace the silver in photographic print paper with other metals or with dye, either of which would change the overall color of a print. Toners were originally available in a wide variety of colors and tones but have virtually disappeared from the market since the advent of digital darkroom techniques. Canon's Toning Effect slider reproduces four colors of toner: sepia, blue, purple, and green. The program also allows you to mix a Filter Effect and a Toning Effect, which can result in some interesting combinations.

Sepia Tone with Red Filter.

SHARPNESS

With the exception of Monochrome, all Picture Styles in DPP default to level 3 Sharpness when selected. Sharpness, or the degree of it, is purely a matter of the photographer's taste balanced against the subject matter. Most family portraiture should not be critically sharp, if for no other reason than to spare your subjects the reality of time, whereas a great deal of advertising's portraiture (and most product photography) needs to be sharp as a tack.

These two comparison images show the range of sharpness available with DPP. In Standard Picture Style, the first shot is set at zero, the second at 10.

Zero sharpness. Sharpness level 10.

RGB IMAGE ADJUSTMENT

You can continue to fine-tune your image by selecting the RGB Image Adjustment button, found at the top of the Tool window. Here you'll find what looks like a traditional histogram. Although it shares some of the functions of a histogram, it's actually a Tone Curve Adjustment and, as such, combines the best of Photoshop's Levels and Curves and Canon's DPP.

As with Photoshop's Curves, you create a break point by clicking and dragging certain portions of the graph line, changing the tones, contrast, and brilliance of the image. For general corrections, Canon has installed two basic curves, found as buttons next to the Revert button.

At the top of the chart, you'll see four boxes: RGB (changeable to Luminance in Preferences), R, G, and B. Selecting any of the individual channels allows you to make a Tone Curve correction to just that channel. So, whereas Luminance mode allows us to make general corrections over the full RGB spectrum, Luminance, along with changes made to the individual Red, Green, or Blue channels, provides more than selective retouching, individual RGB tweaks provide even more creative opportunities. You can place up to eight break points on each of the four lines.

Finally, just in case you missed this before, Canon's placed another white balance eyedropper right where you need it, on the end of the

row. Click on a white or gray portion of any image (if either exist in the image) to neutralize the entire image.

Because most of the items in the drop-down menus are duplicated as buttons or selections in the Tool palette, I was able to do everything I've shown you so far without using any of those menus. There are a few exciting and innovative items hiding in Menuland, however, and we need to take a look at them.

RECIPES

You may have noticed some commands in the File and Edit menus that sound a little strange. There are, in fact, seven commands that cryptically reference "recipe." Well, DPP keeps a running tab on all the changes that are made to an image until it's finished and converted to a TIFF or JPEG. The final version of all changes made to an image can be saved and, like a recipe, applied to another image to make a new one that's just as tasty as the first.

It took several minutes to get this particular effect, and I often reset a control because I didn't like what I saw. I radically changed the dynamic range, exposure, contrast, and individual RGB channels, as well as the entire Luminance tone curve. Before converting it to a TIFF, I selected Edit> Save Recipe in File, named it, selected a location for it (I created a Recipe folder), and clicked Save. That's it. Now I can apply this recipe to any photo I wish, now or in the future.

To use the recipe (or any other that's been saved in the created Recipe folder), first select a new photo in

the Edit window or in another RAW file folder. Go to Edit>Read and Paste Recipe from File…, and select the proper file and recipe. Go back to Edit>Paste Recipe to Selected Image. The new image will be processed according to the recipe in just a few seconds.

DPP can also trim your images on the fly, to any aspect ratio you wish, by using the Trimming tool found under the Tools menu. Calling up that tool will send your selected image to a new window, where you'll see the Aspect Ratio palette. You can choose from a number of presets, or select Custom and simply type in the dimensions you need. If you want to crop without a ratio, just select Free and crop as you wish.

Unless you return to the last saved settings or revert to the image's shot settings, DPP will produce a trimmed file each time you process that file from now on. You can easily tell if the image has been trimmed because the crop will show on the image's thumbnail.

If you'd like to check for areas that may be too bright or too dark for reproduction (this series was deliberately overexposed on the sides) go to View>Highlight or View>Shadow. DPP's default highlight warning is 192, overly cautious perhaps, but you can change that level in Preferences.

The final selection, NR (Noise Reduction)/Lens, reduces noise in RAW images beyond what the camera is capable of. Even if you used either High Speed Noise Reduction or Long Exposure Noise Reduction in the camera, residual noise may remain. This function further tempers the noise levels.

The Lens function is for correcting peripheral light dropoff (vignetting) seen with some camera/lens combinations as well as chromatic aberration also possible with some lenses. Canon has included a list of cameras and lenses that this function may be used with in the instruction manual found on the second CD included with the camera.

For all its depth, DPP is remarkably easy to use. I'm certain if you just jump in and play with it you'll find it will do everything you've always wanted in RAW conversion software, and more.

PICTURE STYLE EDITOR

For those of you who think five color Picture Styles just aren't enough, Canon's Picture Style Editor (PSE) will let your creative side

Original image

shine. Use this software, a reference Picture Style, and a RAW image to create your own Picture Styles for use in DPP or registered to your camera to be used whenever you wish (via EU).

You will have to play with this program to understand its subtleties, but it is a lot of fun. Personally, I like to create narrow, color-limited .pf2 files and apply them to dissimilar images, just to see what happens. I'll be honest—this experiment mostly fails because the effects I like are so narrow. When it succeeds, however, the resulting images can be wonderful, impossible to create any other way.

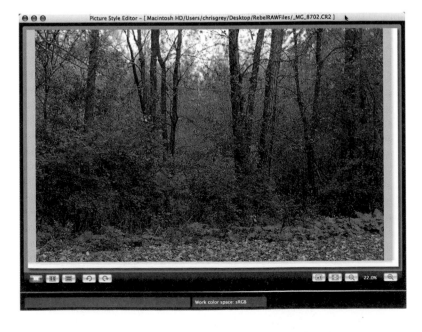

To use PSE, open the program and drag a RAW file into it.

Should your image require exposure or white balance adjustment, select Tools> Preliminary Adjustment and make appropriate changes.

You have the option of working on a full window image, an image at 100%, or a split screen to compare your before and after changes. The horizontal split screen used here displays the adjusted image on the bottom. A vertical split screen is also available.

Use the View menu to select Navigator. You'll use the Navigator to change the display position for the screen, display the image's

histogram in RGB values, and set warnings to prevent excessive levels of brightness/darkness. If you check "Show warning on images," any excessive luminance or color value change will cause portions of the image to blink.

Your other tool is the Tool Palette. Use the Tool Palette to make adjustments to the image, which you'll be able to see on the screen almost immediately. Additionally, you'll use this function to select a base Picture Style and to adjust color saturation, contrast and sharpness, color tone and gamma, and brightness and contrast.

Click Advanced on the Tool Palette and the Advanced Picture Style Settings window appears. Drag each slider where you want it and click OK. The results will show immediately in the split screen so, if you don't like the result, open the Advanced Window again and click Reset.

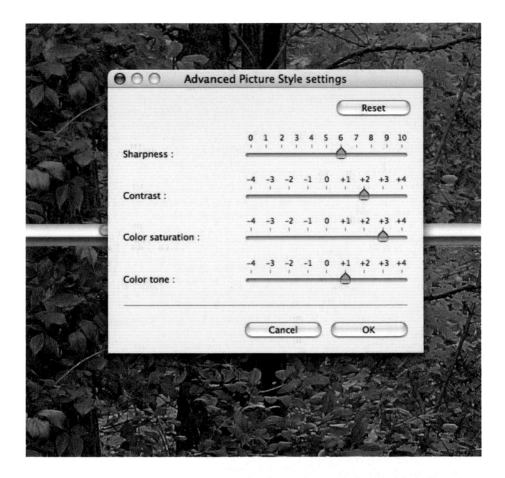

Use the Eyedropper to select a color in the image that you wish to enhance or change (I chose the lighter green of the leaves). The Eyedropper selection will be indicated on the Color Wheel along with a triangle selection, called the Range of Effect, which represents the limits of color that are affected by the selection. This range of effect may be shortened or lengthened by grabbing one of the markers with the cursor.

Use the Hue, Saturation, and Luminance sliders to fine-tune the Range of Effect. These sliders have no influence on any color outside the range.

Repeat the Eyedropper selection if you wish to adjust any other colors.

There are variations on this technique, all spelled out in the manual, that you should play with when you have the opportunity. To this effort, however, all that's necessary is to select the Save Picture Style window (File>Save Picture Style file). Follow my instructions, and you may use this new Picture Style, Autumnal Passion, on any image you wish, whether it looks good or not.

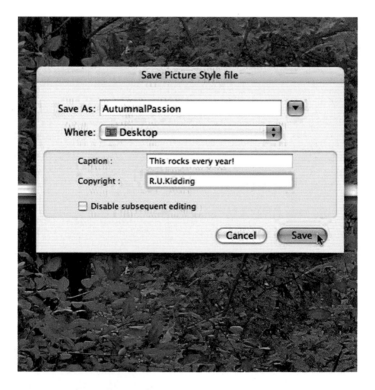

To access the new Style, open DPP and select the image(s) for the Edit Window. For Picture Style, find Autumnal Passion by clicking Browse. You'll find it by title wherever you left it, but it will be noted by however you captioned it.

Select it and process the image. It baffles science!

After applying Autumnal Passion.

Another image, before AP treatment.

After treatment with Autumnal Passion.

IMAGEBROWSER

This is the software you'll use to download, edit, organize, and print your images. Basic steps may be all you need, but there are many advanced features as well.

DOWNLOADING IMAGES

Connect the camera to the computer as instructed in EU and launch ImageBrowser (IB). Turn the camera on. EU will launch automatically. Select "Starts to download images" to begin the download.

As images begin to download, a Quick Preview window appears and presents, well, a quick preview of each image as it's transferred. You can cancel this, if you wish, but I'll bet you won't. This is better than the LCD and faster, too.

You can also download from a card reader. After you start IB you'll be prompted to select a destination folder, after which the Download Images window appears.

After the images have been downloaded, find the correct folder and click it. Your images will appear in the Browser window. Selecting individual frames will enlarge those images in the center window. You may select multiple images by holding down the Command key (Mac) or the Shift key (PC).

Selecting SlideShow from the bottom row will launch a new window that will cycle through however many images you highlighted.

The next command over, Print & Email presents a number of options for sending the images directly to a printer or creating email shots for family, friends, or clients. This example would send the highlighted

images to a printer for an index print. If you wished to email one or many of these, you'd be guided through the process until the images were the correct size for email. When finished, the email application is launched and you can attach the new file or simply drag it to the copy block of the email.

IB defaults to Preview mode, but if you'd rather see your images as thumbnails, change the selection to List mode.

Change the display magnification level by dragging the slider in the middle of the window.

If you wish to see a larger version of any image, just double-click it or select View Image from the bottom of the window. A new viewer window, larger than the IB's, will appear.

The new window features a number of additional commands not found on the main screen. Edit, for example, allows you to do many things traditionally done in other software like Photoshop, such as Sharpness and Tone Curve adjustments or cropping (yes, they really did misspell "trimming."), although IB's crop tool has built-in aspect ratios for panoramics and other styles. There is also an option to add text (and import date and time data, if you wish). Each Edit function opens in a new window.

Synchronize is interesting, because you can compare up to four images at a time, previously selected in the Main window, moving an "enlargement position" indicator anywhere in any of the four navigation windows. Each display synchronizes with the others so that the exact position of each image can be compared. You will need to select 4-Page View from Number of Displays before selecting Synchronize.

Full Screen darkens the entire monitor screen to black and places the image onto the black field for the largest possible view. Click anywhere on the picture to return to the window.

Print is a little different than the function in the Main window in that only the Photo Print window will be shown. You can still add text or crop the image before sending data to the printer.

Sort images by selecting some or all of the thumbnails in the Browser window. Click on any one of them to call up the View window. Use the Back and Next arrows to move through the selection. Assign values one, two, or three stars to each one (each image is assigned two stars by default—Canon knows you can shoot better than they can spell).

Based on the number of stars assigned to the images, you can extract your favorites from the file and place them in a new folder. After you've assigned stars, go back to the Browser window. Select Filter Tool and uncheck each level of stars you wish to hide. What remains will be your favorites.

Go to the Folder list to the left of the Browser window and select the main Pictures folder or another of your choice. Go to File>New Folder, give it a name, and click OK. With only your favorites selected, use Select All and drag the favorites into the new folder.

You can transfer shots from IB to other software for editing or enhancement by "registering" it with Image Browser. Go to IB's Preferences. Select Register Application>Add. Your computer's Applications window will open. Find the program you wish to authorize, such as Photoshop, and Open it. Click OK.

Back in the Browser window, find the image(s) you wish to transfer. Use Edit> Edit with Registered Software>(your Application of choice). The image will be transferred to the authorized program for editing. Once those changes are made and saved, the saved image is returned to the ImageBrowser file.

PHOTOSTITCH

PhotoStitch is a fun little addition to ImageBrowser and is now a lot faster than it used to be. With it you can stitch together up to four individual images and create a panoramic image that's impressively long and cool to look at.

In ImageBrowser, select the images you wish to overlap.

Use Edit>Menu>PhotoStitch to start the program.

_MG_5854.JPG _MG_5855.JPG _MG_5856.JPG _MG_5857.JPG

Check the arrangement of the images in PhotoStitch's window. If they're not in the correct sequence, now's the time to fix them. If you're happy, click 2. Merge. You'll be prompted to click Start.

When you click the Save tab, PhotoStitch automatically draws crop for any uncommon areas, such as you'd get by handholding the camera (as I did) and raising or lowering the horizon slightly from shot to shot.

SHOOTING TIP

Multiple images for panoramics are best shot in Manual and with Auto Focus turned off. Subtle light changes between frames will mean slightly different exposures from frame to frame, destroying the visual integrity of the final image. It's also a good idea to use a tripod, perfectly leveled, of course, but that's not always practical. Use one of the Focus Points as reference and keep it on the horizon for each shot. Overlap the end of each image by 30% so PhotoStitch can find enough common lines to make a flawless final image.

Click the Save button and you'll be prompted to name the final image and to find a place to put it. Photostitch will now merge the frames and make the final.

Light

NATURAL AND AMBIENT
NATURAL LIGHT

Working with natural light means working with what the sun provides, good or bad. Although the photographer can add some measure of flash to fill in shadows (see Flash), this portion of the book deals with images made only with light that's available from the sun.

There are many ways to work with natural light, indoors or outside. Indeed, some photographers work with natural light exclusively. They're comfortable with it, understand it, and have built a career around the look. It's not always easy to do, especially if a shoot has been booked for a day that turns out to be dismal and rainy, but these photographers thrive on the natural light challenge, even though the shoot may have to be rescheduled more than once.

Daylight

Photography in full daylight can be problematic because shadows can be deep and contrasty. Also, when the sun is high, the shadow it throws can be unattractive, especially on people. Squinting is also an issue, and it's difficult to get an unstrained expression when the sun is in your subject's eyes. These are a few of the reasons why seasoned photographers avoid midday hours, although the shadow angle problem is worse in the summer when the sun is more directly overhead.

One solution is to put the sun behind your subject. Backlighting can be an effective and beautiful solution but will introduce its own issues. For example, if you use a metering mode that encompasses too much of the viewfinder, the meter may correctly expose the background but underexpose the subject. This image would have been better with spot metering, at least on the subject, but more of the background would have been correspondingly overexposed.

Moving the subject into an area that's dominated by nonlit shapes forces the meter (in any mode except Spot) to give precedence to the unlit tones. The sunlit background is still overexposed, and the end result is much more pleasant, but the lack of front light and the wraparound effect of the backlight renders a result that needs improvement. This is a good opportunity for fill flash (see Flash), which I used (with the Ultimate Light Box modifier) to create a visual situation that's completely believable and natural.

If you must work with the midday sun, the best light will come from a sky with a light overcast. High, thin clouds effectively turn the entire sky into a large softbox but maintain enough directionality for shadows to form. The softbox effect will open any deep shadows and give an impression of light that's closer to what we see in our mind's eye when we think of someone in that light.

Open shade is a term used for indirect sunlight. In other words, if a subject is lit by light that bounces into an area that is not receiving any direct sunlight, that subject is in open shade. Even though there is a White Balance preset for open shade, you should consider where the light is coming from before using it. The Open Shade preset is designed to add warmth to what is typically cooler light (shade at high noon) and may not be the correct choice if the light is warm to begin with. This dog's portrait was made on a porch against a warm-

toned home, so the daylight that bounced in was actually warmed as it bounced off the house.

Should you be in a situation where light is bouncing strongly off the side of a building into otherwise shadowed areas, take a look at the quality and color of that light. Cold-toned structures will bounce cold-toned light, a good argument to use Auto White Balance (for neutral color) or the Open Shade or Cloudy presets (for warmer color). Should the structure be warm in color, as it was in this young woman's portrait, Daylight is the correct preset if you wish to retain the actual color of the light.

There are a million variations of daylight but only six unchangeable presets. Personally, I think the Open Shade and Cloudy presets should be ignored because they will change the character of the light you see into something it's not. Using the Daylight preset will keep some of that character in the final image. Similarly, AWB should be avoided because it seeks to neutralize any color balance it sees. This image, using the Daylight preset, retains the subtle color of fog in a rainforest, a color that would otherwise be lost or changed.

Another aspect of daylight that presents many interesting photo opportunities is when it's almost nonexistent, the kind of light you might find in an alley or in one of the concrete canyons of Manhattan. Your exposures will be longer than usual or you may have to bump up the ISO higher than you typically would, but the results can be worth it. Deep, saturated color in cool light and short focus can contribute to beautiful images.

When you come across such a scenario, try using the Standard Picture Style and the Daylight white balance together.

You may have heard the term "sweet light," used to describe the light thrown by the sun in its last half hour (or so) of the day. This is truly beautiful light, warmed and softened by extra atmospheric density as the sunlight fights its way through thicker air, almost horizontally, to the subject. Try this light with images of people or places. Your window of opportunity is short, but the images created within this time frame are uniquely beautiful, mostly because of the color of the light—another argument for using the Daylight preset.

It's possible that some of your best shots will actually happen after the sun sets, because for about an hour after sunset there is still enough light to register both on the subject and in the sky. A tripod and higher ISO are both required, of course, and you may have to focus manually because the light levels are so low the auto focus may have trouble locking on. I've stated earlier that my favorite "everyday" exposure mode is Aperture Priority, which is perfect for images like this cactus (see page 164), made at f2.8 approximately 45 minutes after sunset with a Canon 70–200 mm f2.8 IS zoom lens. In subjective situations like this, let the camera find the exposure. It will.

AMBIENT LIGHT

Light that is incidental to the scene you're photographing is called ambient light. Yes, totally natural light can be rightfully called ambient, even though the term often includes a mix of natural and artificial light sources or artificial light entirely.

In many situations, AWB can be the best way to achieve neutral white balances in difficult images. The problem is in determining how neutral you wish the light to be. Many circumstances demand a neutral white, and some of those may not actually be achievable with AWB because overwhelming accent color will actually taint the AWB's attempt at neutralization and skew color in the opposite direction. For example, this first image, made under stage lighting and using the Incandescent WB preset, truthfully represents the colored gels used on the lights and preserves a beautiful skin tone on the dancer (see page 165).

When I attempted AWB, the camera correctly saw the overall blue cast from the background lights and did its best to add enough yellow to neutralize that color. It did its job admirably, but at the expense of flesh tones and the beautiful mood light the lighting director threw

at the background. There is no set formula for how much off-color light is needed before AWB will skew the color of the image. This is more a matter of practice and testing, but when faced with a scenario in which the scene is lit with predictable light, you may get better results using a predictable preset.

When the ambient light is bright enough, the Rebel is definitely capable of delivering great images without supplementary lighting. Either

Av or Tv exposure modes work well in this case, but be aware that too small an aperture (f5.6 here), too long a shutter speed (1/10 second here), or a low ISO will present a shutter/aperture combination that may be difficult to use without seeing motion blur.

Situations lit with unusual lighting, such as sodium or mercury-vapor lamps, can be somewhat neutralized with AWB but will give you the most accurate color with a custom white balance.

THE COLOR OF LIGHT

The actual color of light, its "color temperature," changes over the course of the day. Clouds, whether thick or thin, will also influence how your images look. I mentioned previously that the Daylight white balance preset will allow those influences to add mood to a scene without the possibility of being neutralized by AWB.

Early morning light is warm, typically on the yellow/pink side. Air is cleaner in the morning, with fewer airborne particulates to absorb some colors and scatter others as is typical of sunset light, so you usually won't see color saturation issues that may be encountered late in the day. Early morning light is also quite delicate, with a sweetness and clarity that changes rapidly as the sun climbs higher. The first rays of dawn are truly remarkable.

In summer, the general guideline is to not shoot in direct sun between 10 a.m. and 4 p.m. The sun is almost directly overhead, and the light it produces is hot and contrasty, with distinct shadows

that are often unflattering. There's certainly nothing preventing you from taking pictures during those hours, but you'll frequently have to decide whether to sacrifice highlight or shadow detail or work in more shaded areas. Because this image was so rich in shadow detail, I decided to shoot for that rather than the brighter highlights on this woman's face and dress. Even though the background is warm in tone, look how much cooler (and how much more harsh) the high daylight looks on her.

Somewhere around about three-fourths into the day, and once the shadows have lengthened, the contrasty nature of the light begins to diminish. This is the time to get the Rebel out of the bag and start shooting, for this is the start of the best afternoon light. Your camera, set to the Daylight preset, will see light that is richer than your eyes can perceive and will create images with that beautiful, warm bias.

As the last rays of sunlight are fading, take a look around at what they might be falling on. Those last rays, being so close to the horizon, tend to model the shapes they fall on in a wonderful, and very fleeting, manner.

SHOOTING TIP

The last direct rays of daylight do not necessarily appear at sunset. Be aware of how sunlight is being affected by buildings, mountains, or any shape that may fall between your subject and the sun. Paying attention to how the sun is moving and what might be in its way can present stunning photo opportunities if you make yourself aware of how the light is changing. These two images were made over the course of only 14 minutes, as the sun moved between two buildings across the street from this fountain, about an hour before actual sunset.

REFLECTORS

It can often be advantageous to use a reflector to bounce light onto your subject. Collapsible reflectors, made by manufacturers such as Lastolite, PhotoFlex, Westcott, and others, bounce light back to the subject that opens up the shadows and that can be the difference between a snapshot and a salable shot (this image used Lastolite's 36" Soft Gold reflector). Of course, you can clamp the reflector to a stand, but it may be necessary to employ an assistant to hold the reflector while you concentrate on the shot. It's hard to direct a light stand to make a subtle change.

Lenses

In the late 1980s, Canon began replacing its award-winning FD Lens Series with even better glass, designated as the EF Series. This new series incorporated next-generation design specs and was developed with the entire camera line in mind. Each lens starts with an ideal, large diameter mount, which permits perfect communication between the camera and the lens' autofocus actuators and the electromagnetically driven precision diaphragm that controls the iris. Canon's Ultrasonic Motor (USM) was originally meant only for the L series lenses but is now found on almost all cameras in the EF Series.

Here's the real beauty of the EF Series: *Every* EF lens made since the debut of the EOS cameras in 1987 is fully operational on *any* EOS camera, film or digital. Canon recognizes and appreciates your investment!

Canon's EF L Series is the high ground for glass, with aspherical elements (to control distortion), a minimum of one fluorite element (to control secondary chromatic aberration), and ultra-low dispersion (UD) or super-UD elements. Amazingly, Canon developed its own technology, right down to a successful method for creating artificial fluorite.

Shine a light into an L Series lens, and you'll see a spectrum of colors. This is Canon's Super Spectra Coating, a system by which individual lens elements are coated with different substances to, among other things, reduce flare and ghosting (from internal reflections), assure consistent color balance, absorb ultraviolet, and prevent white from shifting to yellow.

The Rebel XSi/450 does not feature a full frame sensor and so has a conversion factor of 1.6. When you multiply a focal length by the conversion factor, that number will give you the focal length of that lens *as your camera sees it*. Thus, a 100 mm lens on a camera with a full frame sensor will have the angle of view of a 160 mm lens on a Rebel.

Angle of view of a 100 mm lens on a full frame sensor.

The same image as seen by the Rebel and its 1.6 conversion factor.

Note that a conversion factor only affects the angle of view of a lens, not its actual telephoto or wide-angle strength.

Canon currently manufactures an impressive number of lenses in its EF series. I certainly don't have them all, and have never wished that I did, but I do have some favorites that I use relevant to what my assignments demand, and I'd like to share those selections with you.

EF14 MM F2.8 L USM ASPHERICAL

This is the widest-angle lens you can currently use with your Rebel, and it will have an angle of view of approximately 22 degrees. Because this lens uses an aspherical lens element, typical "fisheye" distortion is largely avoided, and it functions as an ultra wide-angle instead. And I do mean extreme. With an angle of coverage of 114 degrees, it's the widest L lens in Canon's lineup (as of this writing).

I've found this lens to be wonderful for landscapes and cityscapes; its ultra wide angle of view actually heightens the reality of a scene by visually pushing everything away and expanding perspective or by allowing a foreground object to be much more dominant than it was in real life.

Wide-angle lenses are more prone to "keystoning," an effect whereby vertical lines slant left and right, up or down, from center, and even more so with the ultra wide-angle lenses. Although you can avoid keystoning by placing the horizon of the image across the middle of the lens, the

fact that it can happen can be visually exploited as a way to direct the viewer's eye through the image or to an area of particular interest.

One thing that I've always enjoyed about the 14 mm is that the image is so wide it's possible to crop it to a long, narrow aspect ratio, which gives the impression of a panoramic image without stitching together individual images or when a tripod is not available to correctly line up those individual frames. Cropping also allows you to move the centered horizon up or down to a more compositionally friendly location.

EF15 MM F2.8 FISHEYE

This is one of the most fun lenses Canon has ever built. Aside from its impressive 180° angle of view (measured diagonally across a 24 × 36 mm, 35 mm size sensor), the inherent ability of this lens to distort both foreground and background creates images that are uniquely interesting.

Wide-angle lenses are capable of more depth of field than normal perspective or telephoto lenses. Thus, at small apertures, it's possible to get what appears to be sharp focus from the closest working distance (0.2 m/0.7 ft in this case) almost to infinity.

As with any lens, but certainly true of wide-angle lenses, distortion is minimized when the horizon is framed at the center. Note that the 15 mm Fisheye has an effective angle of view of 24 mm with the Rebel.

85 MM F1.2

This lens is a photojournalist's dream. Super fast and dead-on sharp, its slight telephoto focal length adds charm to the images through a slightly foreshortened perspective. This is a perfect, grab-shot lens for location work, and even though its huge front element (72 mm) adds extra weight, it is the lens of choice for many wedding and documentary photographers on the prowl for the perfect moment.

With a maximum aperture of f1.2, not only is this lens able to function under very low light levels, depth of field at f1.2 is virtually nonexistent. This lens will show an angle of view of approximately 135 mm.

This lens is terrific for portraits. The slight perspective compression that I spoke of earlier coupled with a midrange f-stop of 5.6 or 8 will

hold focus over the planes of the face but begin falling off to a nice blur at the ears and shoulders. At f1.2, however, depth of field is virtually nonexistent, a point you can exploit for outstanding, out-of-the-ordinary images.

TIP

There's a buzzword floating around, *bokeh*, which refers to the quality of the out-of-focus areas in any image where blur is deliberately introduced or used as a compositional element. I understand it came from the Japanese, *boke*, but I'd never heard it until recently and it isn't in my dictionary. I just wanted to pass it along, so that if a member of the photographic *intelligentsia* drops the word into polite conversation, as in "Hey! Nice bokeh!" you won't take it personally.

50 MM F2.5 COMPACT MACRO

Here's an entry-level macro lens that will perform beautifully as it opens up the world of closeup imagery for you. Capable of one half-life-size magnification and 1:1 ratio with the Lifesize Converter EF, this inexpensive and lightweight little lens also functions as a lens of normal perspective that you could use for everyday snapshot photography.

This lens is best for inanimate objects, as you have to move in pretty close to get a tight image, a position some creatures feel uncomfortable with. Still, it can work well with people. Many medical and legal operations and investigators use this lens for the everyday documentation of injuries or evidence.

Please note that the 50 mm f/2.5 Compact Macro is the only true flat field lens in Canon's lineup. If you do work on a copystand this is a lens you really need.

100 MM F2.8 MACRO

Like macro? Take a step up and check out the 100 mm f2.8. Yes, it's substantially heavier than the 50 mm, but it's still inexpensive (for what it does) and also makes a great portrait lens. The Twin Light macro light system and the Ring Flash are built to fit this lens (see Flash).

This lens also delivers true 1:1 magnification, but the extra 50 mm of this lens' focal length allows you to get in really close from farther away, perfect if you like closeup images with a great deal of background blur. At smaller apertures, this lens keeps enough background detail so your subject matter will be tied to it.

By the way, this lens also features full-time manual focus, which means you can make fine adjustments at any time (very useful when doing macro work) while maintaining auto focus capabilities.

If macro photography becomes a driving force in your life, be sure to check out Canon's MP-E 65 mm f2.8 Macro Photo lens. This lens is not inexpensive, but with magnification up to 5× life size, it might be something you'll have to have.

TS-E 90 MM F2.8 TILT/SHIFT

Acting much like a view camera, Tilt/Shift lenses correct image distortion and control depth of field by moving the axis of the lens. Canon makes three focal lengths of T/S lenses: 24 mm, 45 mm, and 90 mm, and although all are manual focus, each will do the same job; it's the applications that are different.

The 24 mm, for example, is extremely useful for architectural photographers, as the keystoning effect one typically sees when rooms or buildings are photographed can be controlled, with vertical lines drawn back into parallel with the edges of the image frame. Additionally, depth of field can be increased by properly tilting the lens into the frame.

A fair portion of my work is editorial, usually involving people, and I'm typically granted a fair amount of artistic license to interpret what I see. For that reason I often prefer the 90 mm, as it can be used to photograph details in what the eye perceives as a normal perspective, as well as to alter details of other subjects by narrowing the point of focus.

When properly used, the TS lenses corrects perspective.

Tilting the elements of a TS lens can shorten focus.

TIP

Here's an effective and inexpensive way to get the use of a few more shutter speeds out of this or any other lens. Any hardware store should have 1/4 × 20 "O" bolts in stock. Buy one and screw it into the tripod socket on the bottom of the lens (or the camera, if the lens doesn't have a socket).

From a pet supply store, buy a nylon dog leash, about a foot longer than your height. Clip the leash onto the bolt, then stand on it to put upward pressure against the lens. This extra stabilization will buy you at least two more shutter speeds (depending on your caffeine intake for the day, of course).

EF70–200 MM F2.8 L USM

It's long, heavy, and expensive, and it's my favorite lens of all time. The quality of this glass is second to none, and I've found it invaluable for just about every subject I like to photograph.

The old rule of thumb for hand-held telephotos was that the focal length of the lens was equivalent to the maximum shutter speed one should use to get a critically sharp image. So, if this lens was being used at its maximum focal length, a cautious photographer wouldn't use a shutter speed slower than 1/200th of a second because of potential camera shake. That's a seriously limiting rule, and one I like to break.

The 70–200 mm incorporates Canon's most advanced image stabilization technology, which lets me break that rule because it will anticipate (based on my movements), and compensate for, up to three shutter speeds worth of camera movement.

Screw a 1/4 × 20 "O" bolt into the tripod socket of the lens or camera.

Attach an inexpensive nylon dog leash.

Step on the leash while pulling up on the camera. You'll be amazed how steady the camera is.

I've found many uses for this lens. As a portrait lens, this glass comes through every time. It's got a nice, snappy, contrast level, great color resolution, and is as sharp as I want it to be (I can change the degree of sharpness in Picture Styles, if I wish).

For travel and stock photography, the amazingly fast auto focus ultra-sonic motor is difficult to fool. Unless I want to, of course, in which case I'll use manual focus to get the image I want.

EF24-70 MM F2.8 USM

Another favorite, the 24–70 mm is an indispensable tool for wedding and event photographers or anyone who likes to rack from wide to normal in split seconds. I know many photographers who carry two cameras, with the 70–200 mm on the second body, switching whenever the situation warrants a change in focal length. It takes getting used to, but once you do you're covered from wide angle to telephoto.

This is a terrific, everyday lens for a lot of photographers. With its fast f2.8 aperture and angle of view equal to 38 × 112 mm, it's perfect for studio work as well as those special moments that frequently cross our paths.

EF24–105 F4 L

This lens has become almost indispensable to me for everyday work. On my Rebel, the angle of view equals a 38 × 168 mm, and I find I can use it for a million different applications, everything from portraits and interiors (although it's not as wide as I would sometimes like it to be) to more specialized shoots. F4 may not be as fast as some would like, but the Rebel's noise suppression technology makes it easy to increase the ISO and still get wonderful pictures.

EF400 MM F2.8 L IS USM

Weighing almost 12 pounds (5.37 kg), this lens is a beast, and not one to just casually toss into your gadget bag for vacation photos at the beach, but it's so cool it's worth lugging around when photography is your living.

Sports and wildlife photographers love this lens. At f2.8 it gathers just about every photon out there, which makes it a terrific choice for games at night or gazelles at dawn. Those of us who shoot stock photography are always looking for ways to separate our work from the rest of the pack, so a lens like this can actually justify its expense (hey, that's what I told my wife).

I've used this lens in a number of situations where glass of a shorter focal length would have produced a much more "normal" looking image. When I'm working with this lens, "normal" is the last thing I'm going to get, or want. This compressed scene began almost 600 feet away from me.

For this particular series of stock shots, I wanted even stronger tele-photo compression than I was getting with the 400 mm. The easy solution was to use the Canon Extender EF 2x II, effectively doubling the focal length of the lens to 800 mm. It cost me two stops, so my available largest aperture was f5.6, but Canon doesn't make an 800 mm. In this shot, made at least half a mile (1.75 km) from my location, notice how effectively Canon's Super Spectra Coating suppressed internal element reflections from the sun, not an easy task with such a bright source.

You can take a trip through a Canon lens catalog and surely find gear that will do whatever you wish it to do. As an avowed generalist, I'm lucky in that I can find something I like to shoot with just about any lens Canon makes. I realize that you may have different aspirations. I'm okay with that. I just want to assure you that whatever you need, Canon makes.

If you're looking for a starter "kit" of lenses that will creatively realize the vast majority of your ideas, let me suggest the following:

- EF16–35 mm f2.8L II USM. I don't have one. The 14 mm aspherical and 15 mm fisheye do nice things for me (and maybe for you), but this lens is an easy and relatively inexpensive way to get into wide-angle. As a lower cost alternative, the EF 17–40 mm f/4L USM is a terrific lens and about half the price of the 16–35 mm f2.8.
- EF24–70 mm f2.8 USM. With its close focusing abilities, this lens is an excellent day-to-day lens and will do beautiful things for you.

- EF70–200 mm f2.8 L USM. I don't have a bad word to say about this lens—it's incredible, right out of the box.

Canon has built several lenses that one could consider "sleepers" in that they're great pieces of glass for less money than you'd think you'd have to pay. Do yourself a favor and check them out.

One of my favorites, the aforementioned 100 mm f2.8 macro absolutely falls into this category.

The EF 85 mm f/1.8 is an awesome lens. I consider it a viable alternative to the EF 85 mm f/1.2 for folks who can't spend the cash because this lens costs generally about 75% less than the 85 mm f/1.2! It's lighter, faster to focus (because it doesn't have the giant elements to move around), and is optically pleasing.

I also think that the EF 28 mm f/1.8 is a great value at around $400. It is quick to focus, nice and sharp at the edges, and a great way to get into a fast lens at a low price. For the Digital Rebel shooter, its effective focal length is 44.8, which could be a nice all-purpose lens (and pretty close to 50 mm, considered "normal" with a full frame sensor).

EF-S LENSES

In 2003, beginning with the Digital Rebel, Canon debuted a new series of lenses, designated EF-S, sporting a new mount designed for cameras with the APS-C sensor and its 1.6 conversion factor. Although earlier Canons, specifically the D30, D60, and 10D, have APS-C sensors, these lenses will not fit those cameras because the lens mount is too deep. The Rebel, 20D and 30D sport mirror assemblies that move the mirror back as it moves up. If you could mount an EF-S lens on a 10D, for example, the mirror would smack into the lens mount with the very first exposure. That would be bad.

The EF-S lens, right, features a deeper mount than the EF lens on the left. EF-S lenses will currently only fit the Rebel and the Canon 40D.

The lenses were designed to be lighter, smaller, and less expensive, which they can be because the camera sensors are smaller and the circle of light is correspondingly small. There is nothing to be gained by a circle of light that's larger than the sensor, a fact Canon took into account.

There are currently five lenses in this series.

EF-S 17–55 MM F2.8 IS USM

This is the most expensive of the series, currently almost $1,200. What makes it interesting is that it comprises the requisite number of exotic elements (fluorite, aspherical elements, etc.) to qualify it for L-Series inclusion. (It can't be an L lens because it doesn't fit all the cameras.)

For everything that it packs into its 4.4-inch, 22.8-ounce weight (110.6 mm, 645 g), it's a great piece of glass. The conversion factor effectively makes it a 27–88 mm zoom.

EF-S 10–22 MM F3.5–4.5 USM

Ultra wide-angle coverage, aspherical elements to control distortion, and focus as close as 9.5 inches makes this lens a great choice for the Rebel. The conversion factor means you'd have a 16–35 mm, one of the most popular choices for wide-angle lenses. Full-time manual focus means you can tweak focus anytime, even when using AF.

EF-S 17–85 F4–5.6 IS USM

The equivalent of a 27–135 mm on a Rebel, this lens also features Canon's image stabilization, allowing you to shoot under lower light conditions than you normally would be able to use. This strikes me as a useful lens for event photographers who shoot with flash. I think the f5.6 maximum aperture (at 85 mm) would be limiting without flash, but the price is certainly attractive, currently about $515, and you're certainly not limited to just flash work.

EF-S 18–55 MM F3.5–5.6 IS USM

This is the standard kit lens that Canon lets you purchase for next to nothing when you buy a Rebel. Some photographers have indicated

they feel the lens must be pretty bad or Canon wouldn't sell them so cheaply. They couldn't be further from the truth, especially with the built-in image stabilization.

I had the opportunity to work with this lens for quite a while when writing this book, and aside from my professional reservations about f5.6 as a maximum aperture at full zoom, I have to say that I was impressed with its performance. It focuses accurately and quickly, the zoom ring is smooth, and it weighs almost nothing. Believe it or not, this image of the moon and city-lit clouds was *hand held* for a 1-second exposure. Not bad for a cheap lens, huh?

EF-S 60 MM F2.8 MACRO USM

I love lenses like this. At 60 mm (an angle of view equal to 96 mm) it's a lot like the 100 mm macro I wrote about earlier, so it functions like a short telephoto, makes a great portrait lens, and delivers 1:1 macro. It's a sleeper, too, and a great lens for the money.

A final word about EF-S lenses. If you think you'll move up to a camera with a larger sensor, you might want to stick with straight EF lenses. After all, they fit every DSLR in the line.

The Subjects

PRO TIPS AND TRICKS FOR GREAT IMAGES!

The Rebel is an amazing camera, and that's not an overstatement. With its Mark III technology it's capable of returning great images of just about anything. As a professional photographer, I've picked up a number of tricks and habits over the years that have defined my style. If you're new to the DSLR world, or to photography in general, here are some of my favorites. I hope they will help you find your style as well.

PEOPLE

Watch for the "moment." Interaction within a group, large or small, will tell the tale much better than a static shot of people looking at the camera. Try to be unobtrusive. Keep the camera to your eye, making exposures as opportunities present themselves. Above all, avoid the urge to "chimp" your images, looking at the LCD after each picture to see what you got. It's distracting to the subjects, onlookers, and you. Besides, you might miss something.

Isolate your subject. Use a telephoto and a large aperture (200mm and f2.8 in this case) to put emphasis on the subject by making the background out of focus. If at all possible, try to position yourself so that the background is at least partially in shadow. Doing so will lend additional emphasis to the subject. Nice bokeh!

Pan the camera. Following action and using a slow shutter speed (1/5 second here, but shutter speed should be chosen for the speed of the action) results in a partially blurred image with some portion of the image recognizably in focus. To pan the camera successfully, find the subject and start panning before tripping the shutter. Note the location of the part of the image you want to remain important and its place in the viewfinder. Keep it there for the duration of the pan. It's also a good idea to pan past the end of the exposure, as you'll avoid stopping the camera movement too soon.

If you're working in the Basic mode, the flash may pop up. Switch to Tv, and set the shutter speed you want. This shot would be lifeless if the flash had gone off.

Wait for the peak of the action. When something moves back and forth, there is a short time at each end of the arc where some action freezes. Situations like this require a shutter speed fast enough to catch the peak but slow enough to allow faster movement to blur. This hula dancer was photographed under stage light at 1/15 second, f3.5, ISO 400. The Tungsten (Incandescent) white balance preset was also used, along with Continuous Shooting, to increase the chance for a successful image, as it's almost impossible to get this with just one shot.

Follow action with Continuous Shooting and AI Servo. It looks brightly lit, but this waterfall was tucked away in a dark rainforest and it was an overcast day, which necessitated using ISO 1600 to get the fastest shutter speed possible, 1/200 second. Focus was locked on the diver as she stood on the rock, preparing herself. When she flexed

her knees I started shooting, following her fall by keeping her in the same place in the viewfinder as long as possible.

Use Av to mix flash and ambient light. The Av mode will keep the shutter open as long as it takes to get a proper exposure of the ambient light in any scene, a feature you can exploit for shots like this because Av takes no notice of the flash. In other words, if the correct exposure of a scene is 5 seconds at f5.6, that's how long the shutter will stay open. If the ambient light is falling primarily on the background, as it was here, the camera's flash will illuminate the subject while the ambient illuminates the background. It takes some practice and not every shot works, but it's beautiful when it does.

TRAVEL

For photography buffs, travel is more of an adventure than a vacation. My camera is always with me when I travel because I consider photography such an integral part of my psyche that I just can't leave it behind. Taking pictures is just too much fun.

Watch where you're going. Whether you're shooting just to document your trip or to fill your stock files, be sure to stop when the scene looks "right" (and when it is safe to do so, of course). As an aside, colors are almost always more saturated after it has rained.

Wait for "sweet light" whenever you can. At the magic hour just before and immediately after sunset, colors are warm and rich, unlike you will see them at any other time of the day.

Look down. Great compositions are not always found at eye level. This plant was slightly off the path, but moving the camera closer to it and pointing the lens down in an atypical manner revealed this unusual view.

Isolate details. Much as you would with people, get close to the subject with a longer focal length lens and use a large enough aperture to gently blur out the background.

Use local architecture to frame areas of interest. If the exposure had been made for the buildings, the resulting overexposure of the landscape would have made a rather ugly picture. The landscape by itself would have been just as dull, given the early morning fog. As it is, the buildings add a sense of interest and antiquity to a tranquil scene.

Use shadows to your advantage. Because few people like to see people they don't know in their travel photos (but tourists are everywhere), use building shadows to silhouette your fellow travelers and add visual interest to your shots beyond simple documentation of your location. Also, try to keep your fellow travelers' backs to you. That makes them even more anonymous.

Anonymous people add interest to patterned compositions. Architecture, and the repetition of detail, presents many opportunities to record line and form, and you should certainly take advantage of that whenever possible. Images of this nature, however, are actually improved by the addition of a human being into the shot, because the scale of the building becomes apparent as the design becomes humanized. Obviously, this is not a situation that you can control, but you certainly should photograph it when it arises.

Use Exposure Compensation to saturate the colors of sunset. Depending on which metering mode you use, you may find it valuable to dial in Exposure Compensation to get even richer colors than your eyes will note.

The first image, using the Av mode, did a terrific job of photographing exactly how the sky looked just a few moments before sunset. The second image, made just a few moments later with a −1 stop Exposure Compensation, represents this sunset more as we imagine it. This is now one of those idyllic images we see in our mind's eye.

Shoot the icons. In hundreds, if not thousands, of locations around the world there are iconic images that represent the location. For almost 70 years, the USS *Arizona* has been leaking a small amount of oil a day since it sank in 1941. Arguments have been presented on both sides for stopping it or letting it continue. The point is that those leaks represent the monument possibly more than the actual monument itself.

In situations where I'm photographing many items or situations over the course of the day, I've found it valuable to also photograph my notes. When I find an item of interest that's not immediately identifiable I'll make a note with a black marker in a small notebook that I keep in my gadget bag. The marker makes the note easy to read, even from a catalog thumbnail, and helps tremendously when I need to identify a subject.

The best part? It costs nothing to shoot the note, which stays with the file unless you delete it.

You can also take a picture of a menu, napkin, or other identifier to help you keep track of where you were or what you did.

Bad weather is your friend. Don't hunker down in your hotel room, get out there and shoot. This blizzard was a nasty event that lasted the better part of two days, caused me to miss a flight, and basically made my life miserable as far as my actual job was concerned. The bottom line, though, is that its ferocity was photographically beautiful.

In between my actual location job, I made several hundred images of this blizzard within just a block or two of my hotel. Yes, it was unpleasant, but so what? If the picture's everything, what's a little frostbite among friends?

Shoot after sunset, but try different presets. Your Rebel's sensor is an amazing instrument. Using the Av mode, the sensor can read and communicate a correct aperture/shutter combination to the processor to produce wonderful images for you, but, as I've noted before, different Color Balance presets produce different colors.

You'll need to use a tripod anyway, so take another minute or two to rack through the choices, just to see what might happen. This first image was made with the Daylight preset, the second with the Incandescent preset.

By the way, your Rebel is perfectly capable of metering moonlight as well as sunlight. Should you be lucky enough to see the moon rise behind a nice composition, well, bang away. You may need to do some Exposure Compensation, because the moon will be such a bright spot in the dark heavens, but playing with the camera will be worth the results.

PETS AND WILDLIFE

Animals are fun to shoot, and I don't mean that in a bad way. Animals, each with its own personality, make marvelous subjects for your camera, even if you have to actively seek them out. House pets? A favorite subject, always, just for grins.

Get in close. My wife and I were invited to visit friends in Costa Rica, and, naturally, I took a camera. After dinner, while enjoying an adult beverage, we heard noises that sounded amphibian but were much louder than what we'd ever heard around the Minnesota lake near our home. Our friends explained that local frogs found their way into the swimming pool every evening, had a great time while making a lot of noise, and left as the sun came up.

This, I had to see.

With my 70-200 mm f2.8 lens, I tried to be as stealthy as possible as I made my way to the pool. Little did I know that the frogs couldn't have cared less about my presence, showing little or no apprehension when I got on my knees and lowered my camera down to their

level. This big guy, who might have defied me had I been wearing a Speedo, instead let me shoot multiple frames at f4 with a bounce-modified flash until he tired of the publicity and scooted off to the other side of the pool.

Watch and wait. Take note of places where wildlife will gather, pull up a chair, mount your telephoto lens, and wait for the moment. As always, large apertures will limit the depth of field in an image and blur the background.

In most small towns in Italy, town cats own the city. Everyone knows who they are, feeds them, even cares for them if necessary. They are not only known to the townspeople, they're also known to local pets and are greeted with anticipation and affection. Should you see this scenario unfold, shoot throughout the episode. If a local townsperson walks into camera range, keep shooting. There will be one frame in the group that sums up the entire experience.

Get down to your pet's level. You'll get a peer's eye view of your little friend.

Pets do funny, stupid, things because they're comfortable with us and love us. Keep your camera at the ready. They won't mind a shot or two.

HUMOR

Always, no matter where you are, keep your eyes open for humorous moments. It doesn't matter where your sense of humor leads you because your audience, familiar with your sense of humor, will laugh at your ability to see the world the way you do.

Accessories

ACCESSORY FLASH

As you'll become more familiar with your Rebel, you'll discover that there are things you wish you had to make your shooting life easier. Canon has manufactured a significant number of accessories for the Rebel that will do the job for you, whatever that job may be.

It's not necessary to rely solely on the built-in flash. The accessory shoe on the top of the camera will communicate directly with Canon flash units, Speedlites, to deliver flash images beyond the capabilities of the built-in unit.

At the time of this writing, Canon's accessory strobe flagship is the 580EX-II. Along with its full-featured little brother, the 430EX II, these slim, relatively lightweight products will do wonderful things by themselves or linked with additional units (I've heard of as many as 36!). Unlike earlier units, the EX-II adds Auto to its Mode list (via a Custom Function), a feature many photographers feel gives the Speedlite line an option the photographic community says it wants.

E-TTL mode fires a small flash immediately before firing the main burst. The unit reads the amount of light bouncing back from the measuring point and shortens or lengthens the second flash duration accordingly. Auto mode fires one shot at essentially full power, reads the bounce, and turns the strobe off when the correct amount of light has hit the sensor. Many photographers feel Auto to be more accurate than E-TTL.

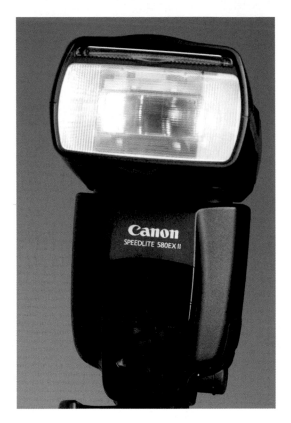

When using the flash with a wide-angle lens, use the built-in plastic baffle to spread the light more evenly to the sides. Without it, you may find the light will fall off and form a vignette.

One drawback to using bounce flash, wherein the unit is aimed to the ceiling or wall, is that your subject's eyes will not show a catchlight. To add life to eyes, use the white, popup reflector to direct a small amount of the main flash toward your subject.

No matter how you cut it, the 580 is considered a small unit, with a guide number of 58. Although it's capable of a strong burst at full power, it isn't typically used that way in E-TTL, where recycle speed is important.

I've found a few tricks, over the years, to get more consistent results from my Canon flash in E-TTL, and I'm happy to share them with you. Some of these tricks are based only on my experience and observation, but they seem to work nicely and improve my shot-to-shot success ratio.

The most important tip is that E-TTL seems to work better with an ISO higher than 100. When I fire up my flash unit, I'll set my camera's ISO to at least 400. This helps because the unit doesn't have to push out as much light as it does at my preferred ISO of 100, and it can light the scene more efficiently.

The units have a built-in power adjustment that you can use to increase or decrease the output power relative to what the camera thinks it wants. This is just like the Flash Exposure Compensation function dialed in on the camera with built-in flash, except that the adjustments are made on the flash unit itself.

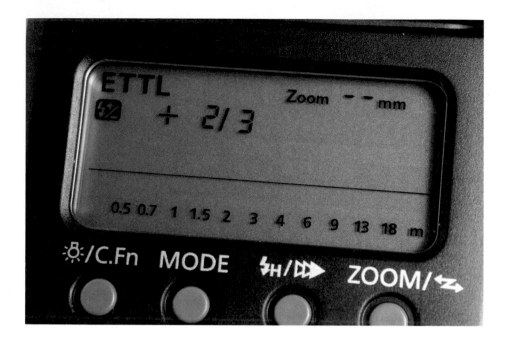

I've also found that zoom lenses are definitely the way to go when using accessory flash because, at 7 to 10 feet, the flash is working at its best. The distance from the subject is not so far that the flash has to work overtime but far enough so that the spread of light is even and consistent. My preferred lens in this circumstance is the 24–105 mm f4 IS L zoom, because I can let the lens do the work of moving in or out of the frame. It's also a good idea to use a maximum aperture of f5.6 (larger is better) whenever possible.

Even when you've nailed your E-TTL flash, you're still dealing with a small, specular, light source. Better results are obtained when you use a third-party diffuser to broaden and soften the light source. Many of these devices are on the market, and I certainly haven't tried all of them, but there are some characteristics that each exhibit: Any of them will spread the light, creating a larger, softer, source, and each will cut the efficiency of the source, the power of the strobe's output, by at least one full stop.

My favorite, the Ultimate Light Box System, is a beautiful mini-softbox that's engineered to fit snugly right over the flash head. It's supplied with a series of baffles that can be inserted or removed; these modify the output for a softer or more specular light. It's a beautiful, modular system.

A look that I really like is when a flash fill is not noticeable but looks like it was part of the ambient. In other words, the fill is so soft that it is unrecognizable as fill flash, except, perhaps, in the catchlights of the eyes.

Try this with your favorite third-party modifier. From a working distance of not more than 10 feet, and with your modifier in place and your camera set to Av mode, dial the E-TTL power to $-1\frac{1}{3}$ stops. Be sure to use an aperture that will not require a high power discharge from the flash unit. I think you'll find that the strobe fills in the shadows just enough to make the image truly believable and much prettier than it would have been without the fill. This image was made using the Ultra Light Box.

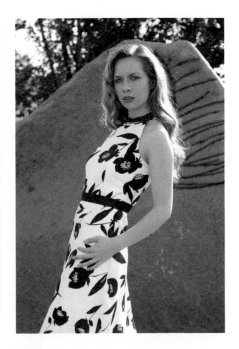

If you want the most controllable results from your Speedlites, you must learn and note their power output in Manual mode. When you know what the true output is, and at what f-stop, a whole new world of controlled imagery is literally at your fingertips.

Canon's Speedlites have many other features, all designed to help you make better pictures.

Flash Exposure Bracketing (FEB) let's you take three flash shots in a row at three different strengths. You can symmetrically vary the power in $1/3$-stop increments up to a plus/minus of three whole stops. The camera will have to wait for the flash to recycle, of course, but if

Normal flash exposure.

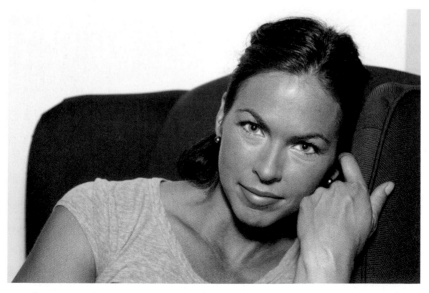

FEB delivers plus one stop.

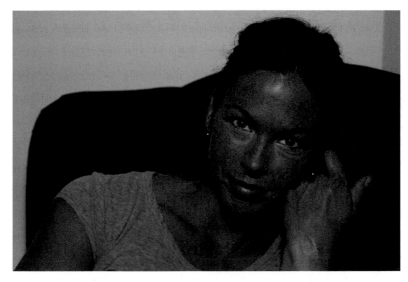

FEB underexposes by one full stop.

you jump the gun and fire the camera before the flash is ready, you won't have to reset the bracket. The flash will hold the setting until a successful discharge can be made and, if you have dialed in a basic E-TTL exposure correction, the flash will add or subtract that correction automatically. You will have to reselect FEB each time you wish to make a new bracket series.

Speedlites offer High-Speed Sync (FP Flash), which lets you use flash at any shutter speed, up to the maximum 1/4000 of a second. To

access it, select the high-speed option from the back of the flash. An icon next to the E-TTL designation will appear in the LCD panel. Note that as shutter speeds increase in speed, the working distance of the strobe decreases. There is a distance scale on the bottom of the LCD showing you the effective range, but only for an unmodified strobe. If you'd like to use a diffuser to soften the light, your best bet might be to use the camera in Av mode and make adjustments via Flash Exposure Compensation. Increasing the ISO accomplishes much the same thing.

Pushing the ISO to 800 allowed more distance between the camera and the subject. Shutter speed was 1/4000 second, the Rebel's maximum.

Toggling the same button that controls High-Speed Sync will access Second-Curtain Sync, a cool tool that fires the flash at the end of the exposure rather than the outset. If you wish to intentionally create a motion blur, flash at the end of a long exposure will freeze time at the end of the blur. The images will have a more realistic look to them. For the most realistic look, be sure all the lights are, or have been gelled to, the same color temperature.

MULTI STROBOSCOPIC FLASH

Multi Stroboscopic Flash is yet another option for the creative photographer. This mode gives you multiple, rapid bursts of strobe fires that freeze movement in multiple positions. Use the images for analysis, like a golf swing, or just for drama or fun.

This feature is just slightly more difficult to use than other modes, but it's not that tough. You'll need to determine the correct exposure strength of *one* flash, in Manual mode, that falls on your subject. Use an external meter or photograph a gray card, adjusting either the flash-to-subject distance or the strength of the flash until you get a perfect, centered, histogram. Make note of the correct power setting.

Now, press the Mode button until Multi is displayed on the LCD. Dial in the same power setting.

For moving subjects that will not significantly overlap, decide how many times the flash should fire, and use the Dial button to find the burst number (it will blink when selected) and the dial to select the

number of flashes that will make up the burst. Note that finding a lower power setting at the start of the process will allow for more flashes.

The Hz setting determines the speed of the burst. Higher Hz numbers mean shorter times between flashes but they also require more power, which is another reason to use a lower power setting if possible.

To find the correct shutter speed for your image, divide the number of flashes by the Hz rate. In this case, the number of flashes is four, as is the Hz rate: 4/4 = 1. The shutter speed needs to be at least a full second long. For this image, I used two additional units for the side highlights.

SPEEDLITES IN STUDIO OR LOCATION

Speedlites can talk to each other and, like humans, can set each other off. You can connect a network of Speedlites together for a basic portrait light setup or to provide accent and background lights for a wedding or other such event. Although Speedlites are small, specular sources, they are, like all auxiliary lighting, tools to boost your creativity and realize your vision. It's simply a matter of how you work with them and how you get them to do what you want.

Earlier 580 Speedlites have a switch on the bottom, just above the shoe mount, that assigns the role of Master or Slave to individual units, but the 580 EX II Master/Slave selection happens in the Speedlite's menu. The unit on the camera is always the Master, and with it, you can control every other Slave unit. Now, there are some caveats. Because the Slave units must "see" the camera unit, you are limited to a spread of 40°, left and right of the lens axis. You will also need to tilt or swing each flash so the infrared signal window (the red window on the front of the unit) is facing the Master. This 80° total is the limit of the infrared signal that the Master will transmit. Working with multiple Speedlites outside, according to Canon, gives you a maximum working outdoor distance of about 26 feet, indoors, almost 50 feet. These are average results, and yours may vary, so test any setup before your put your money on it.

You can program Flash Exposure Compensation, High-Speed Sync, Stroboscopic Flash, or any other feature of the Speedlite (with the exception of Second-Curtain Sync) into the Master, but understand that the same settings will be applied to each of the Slave units. For many images this is totally acceptable. Wedding and event photographers often set several Slave units on clamp mounts in multiple locations in a reception hall, to illuminate backgrounds or add hair lights to create depth and dimension to their images. Should you decide to make a change to the Master, such as adding or subtracting $1/3$ stop of exposure value, the change will be made symmetrically to every Slave unit, although they can be ratioed separately against each other.

> ### SHOOTING TIP
>
> The little stand, the foot, provided with the 580EX II, is best used when the strobe can be placed on a flat, level surface such as a floor or shelf. If you want to place the unit on a stand and have the ability to change its angle, check out the R 4130 Umbrella Stand Adapter from Norman (www.photo-control. com). It's inexpensive and you can thread an umbrella through it, turning your Canon flash into a broader, softer source. If you find yourself in a pinch and need to position another flash at an angle, just screw the foot onto your tripod and use its controls to angle the flash where you need it.

I'm not a fan of on-camera flash as a key (main) light, although I'll admit I've seen beautiful shots made in that manner. I much prefer to

have my key light off-camera, set to camera right or camera left, just to give my subject dimension by throwing a nice shadow. When I do have the Master on-camera, I prefer to use a modifier. The key light for this shot of R&B singer Sahata was modified with the Ultimate Light Box. The Slave units, slightly behind and to the sides of her at camera right and camera left, were gelled with orange.

Canon allows you the option of prohibiting the Master unit from firing, even though it will still send out a signal flash to alert the other units. Being able to disable the Master is an extremely valuable feature because it frees you from the flat-light look that's so common to on-camera flash images made without modifiers.

For studio or location, a nifty trick to increase the apparent size of the light is to place a translucent diffusion screen close to the subject and place the flash a few feet behind it. When the screen lights up from the flash, it acts as a softbox and becomes a softer, broader source. It is best, in my opinion, to set the flash on Manual and meter with an external device. For this image, the Master was disabled, with only the Slave firing. An additional bounce panel was placed at camera right.

MACRO TWIN LITE

Canon makes two special accessory flashes, the Macro Twin Lite and the Ring Lite. Each is mounted on the lens and meant to be a close-to-the-lens source. Although they are similar to the popup flashes of the Rebel, in that they are next to or around the lens, the Twin Lite is a two-light source that can be controlled, whereas the Ring Lite is a bi-tubed, split circle of light around the lens. Both have applications for anyone who wishes to expand his or her visual vocabulary.

Should you be one of the many shooters looking for an edge over your competition or just someone looking for a cool and unusual accessory, check out Canon's Macro Twin Lite MT-24EX.

The first thing you'll notice, of course, are the dual strobe heads, designated A and B. Mounted on a ring that is, in turn, mounted on the lens barrel, both heads can be moved in

tandem around the lens or moved independently by pushing a small release button to any other position. Additionally, each head swivels on its own mount, allowing you to place head A at an angle of 45° to the lens while positioning head B at, perhaps, 75°. Being able to move the two heads separately gives you a great deal of control. Think of one head as the key light and the other as the fill. You may wish to use a hard angle for the key and a lesser angle for the fill, which produces a lighting scenario impossible to achieve with other macroflashes such as ring lights.

In E-TTL, each head can be ratioed against the other, allowing even more control of key (head A) to fill (head B), up to three stops in either direction. Note that, on the back of the unit, the ratio is marked as A:B. This cannot be changed, which is why the ratio scale runs from 8:1 (A being three stops brighter than B, and B is the correct f-stop according to E-TTL) to 1:8 (B now being three stops brighter than A, according to the E-TTL computations). Because the two lights are so close together, the actual difference is a blend of the two lights, although one will be truly brighter than the other.

Relatively strong for a macrolight, with a guide number of 78 (in feet, 24 in meters), this innovative flash does a terrific job lighting a wide variety of subjects and works well in both E-TTL and Manual modes. In some situations, it's even strong enough to overpower the strength of the sun when a subject is fully backlit and close to the camera, a feature that gives you a great deal of versatility within the realm of your work.

In the studio environment, the Canon Twin Lite makes a terrific key light for snappy, on-the-fly headshots whether you use it with other Speedlites, using the built-in infrared triggering device, or simply to set off studio packs. My Twin Lite was set to a 1:4 ratio, with the upper flash being dominant. Notice how nicely the lower strobe fills in the small shadow under the chin.

Foliage in deep shadow can be easily photographed in relief with the Twin Lite. This image, made in E-TTL at f5 in Manual mode and with a 100 mm macro, shows just enough depth of field to give the viewer a strong impression of shape and form.

I was able to overpower the strength of the sun by setting my aperture to f32 and letting the E-TTL function of the Twin Lite throw more light at the subject than the ambient light would ever show. Be aware that proper eye protection is necessary when making images when full sunlight can shine directly into your focusing eye. An optic nerve is a terrible thing to waste.

RING LITE

Canon's Ring Light, MR-14EX, like the Canon Twin Lite, is built to fit onto the 58 mm front of the 100 mm macro, but you can buy step-down or step-up rings so that the flashes can be mounted on lenses with filter diameters other than 58 mm. Because it can act like a continuous flashtube around the lens, it can produce a beautiful, virtually shadow-free light onto any subject. However, the strobe tube is not a single piece, but rather two semicircular tubes that can be proportioned against each other to create a key:fill ratio.

Even though it wraps around the lens, the light it throws is not shadow-free. Instead, a small shadow is formed, symmetrically, around the entire periphery of the subject. The width of this shadow is controlled by the distance of the subject to the background, which many photographers exploit as a compositional element. Canon's ring light, though certainly usable for fashion photography, is also extremely useful as a macrolight. Insurance documentarians and collectors use it routinely, as it adequately represents the planes of important artifacts well enough to establish monetary value. The light is flat but modeled enough so it sees cosmetic damage easily.

Most of Canon's Speedlites work together as a wireless unit, which means you could set up a portrait shot using a Ring Light as the key, a Twin Lite to accent the hair, and a head-modified, standard flash for the background, controlling all of them from a Master flash on camera that you've set not to fire.

There is so much more to Canon's Speedlite system than first meets the eye. Yes, the gear is more expensive than similar equipment from a third-party manufacturer, but the other stuff can't do as much or talk to the camera like native equipment can. If you have doubts about what a Canon flash can do for you and your camera, rent or borrow one for a weekend. Make sure you have the instruction manual. Play, and don't be afraid to mess up. Working with flash is not a trouble-free experience, but I know that when you understand the system, you'll be a true believer.

CAMERA ACCESSORIES

You can extend the shooting limits of your Rebel by purchasing the BG-E5 Battery Grip accessory. The BG-E5, unavailable for photography at the time of this writing, can be purchased with either the BGM-E5L magazine, which holds two LP-E5 batteries, or the BGM-E5A, which draws power from AA batteries. For those of you who need more image capabilities but shoot locally, I would lean toward the BGM-E5L because it can be recharged hundreds of times. For those of you who like to hike through the wilderness, the BGM-E5A would be a better option, as it's easy to carry additional AA batteries with you or purchase them as you go.

Don't like batteries? The aforementioned power adapter, CA-PS700, allows you to run your camera off household power.

Charge your camera's battery in your vehicle with the CBC-E5 Car Battery Charger. This is an invaluable accessory if you frequently travel between shoots and have time to top off the battery.

One of my favorite accessories for the Rebel is the remote switch, RS-60E3. In the studio, if I'm shooting reflective subjects, I may need to duck behind a black shield so my reflection won't be picked up. This accessory allows me to stand at least 3 feet away from the lens. Additionally, if I'm shooting time exposures with the mirror locked up, I can trip the shutter when I'm ready without having to touch the camera and possibly shake it.

Another favorite is the Angle Finder C, a right-angle viewfinder that allows you to see through the lens even if you're backed into a corner. You can also use this accessory to look and focus over a crowd, using the camera much like a periscope.

There are many other accessories, too. Check the Rebel's manual to see what's best for you.

PRINTERS

Canon manufactures a full line of printers, ready for whatever job you care to throw at them. Smaller units, available as inkjet or dye sublimation printers, will do a great job for 4 × 6 prints. Canon's larger units, available as inkjet printers only, can be used to print images up to 36 inches wide, with a length limited only by the limits of your computer or the length of the paper roll or single sheet. All Canon printers are PictBridge enabled, which means you can tether your camera directly to the printer and make prints straight from the SD card.

OTHER ACCESSORIES

So many manufacturers are creating tools for you that it's impossible to list them all or to explain what their goods might do for you. Be assured that, whatever you like to shoot, you'll find tripods, bags, or gadgets to fit your shooting style. For example, you can readily find shoulder bags, backpacks, or rolling gear backs to carry virtually

any configuration of equipment. A little more research will turn up a myriad of tripods, monopods, and specialty pods, from an 18-inch extension to one that is 12 feet or higher. It's all up to you.

I've assembled a list of favorite website links for photographic gear and photographic help, which you'll find at the back of this book. Feel free to surf through them or use your file browser to find others. Take some time to search before putting your money down—there are always alternatives, some of which might do a better job for you than your first choice.

www.harbordigitaldesign.com: Makers of the Ultimate Light Box accessory diffusion system.

www.ShootSmarter.com: Free photo information.

www.ProPhotoResource.com: Free photo information and forum.

www.photo-control.com: Norman brand products and accessories.

www.usa.canon.com: Canon's primary website with access to the Canon Digital Learning Center and other information sites.

www.BalanceSmarter.com: Makers of collapsible white balance targets.

www.Lastolite.com: Makers of collapsible white balance targets and lighting accessories.

http://photography-on-the.net/forum: A forum for Canon enthusiasts.

www.dpreview.com: Information on all aspects of digital photography.

www.MyBWLab.net: The best black and white prints from color files that i've seen.

Index

Focal Press